The 'Great Wilderness'

'Look out of this window, Watson. See how the figures loom up, are dimly seen, and then blend once more into the cloud-bank. The thief or murderer could roam London on such a day as the tiger does the jungle, unseen until he pounces, and then evident only to his victim.'
Sherlock Holmes – *The Adventure of the Bruce-Partington Plans*

On returning to England after military service in Afghanistan, Dr Watson had been inexorably drawn to London even though he openly refers to it as, 'That great cesspool into which all the loungers and idlers of the Empire are irresistibly drawn.' London has sometimes been described as the third character in the Sherlock Holmes stories by Sir Arthur Conan Doyle. It was the perfect backdrop, a busy, vibrant, over-crowed city, constantly on the move and frequently enveloped in thick, swirling fogs. It was 'The Great Wilderness.'

To explore the London of Sherlock Holmes, it is first necessary to define the timeline of his activities. There are sixty Sherlock Holmes adventures: fifty-six short stories and four longer novels. With one exception, when Holmes himself acts as narrator, they are presented as the reminiscences of Dr John H. Watson. The first, *A Study in Scarlet*, appeared in 1887 while the final series of short stories, *The Case-Book of Sherlock Holmes*, was published between 1921 and 1927. When Conan Doyle began writing these stories he

Left: Actor William Gillette was the American face of Holmes. (*LoC*)
Right: Sydney Paget illustration from *The Strand Magazine*.

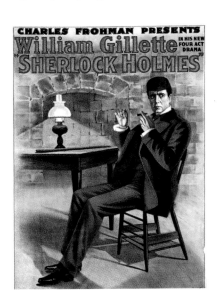

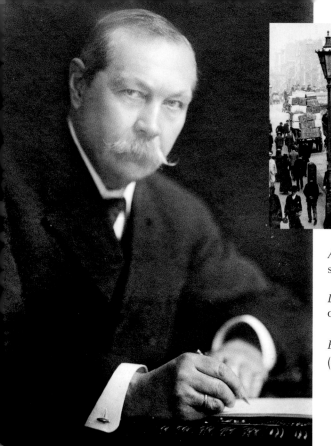

Above: A typically busy central London scene, Ludgate Hill *c.* 1900.

Left: Sir Arthur Conan Doyle, the creator of Sherlock Holmes.

Below: Traffic on Blackfriars Bridge. (*LoC*)

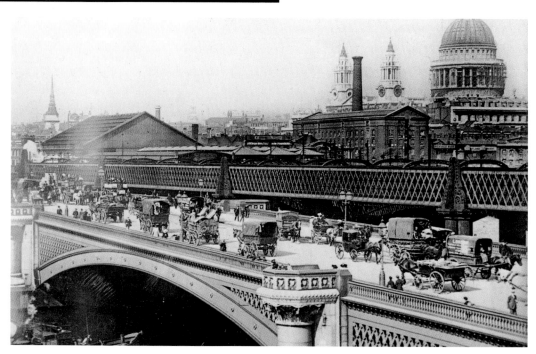

THE LONDON OF SHERLOCK HOLMES

JOHN CHRISTOPHER

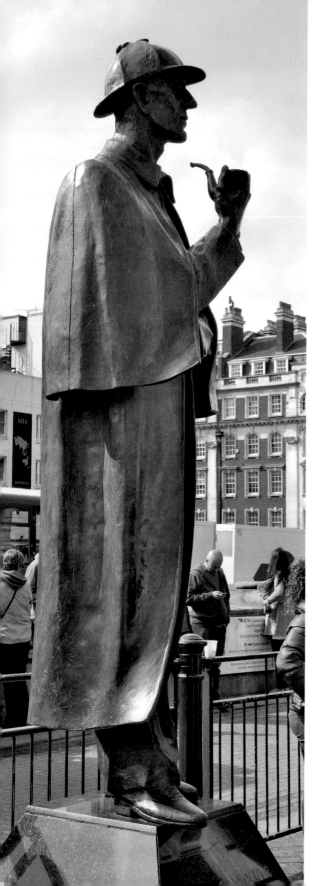

Left: This statue of Sherlock Holmes greets travellers as they leave the Baker Street tube station. His deerstalker hat has become something of a cliché as it was only part of his country outfit, and in the original stories he is portrayed with a variety of headgear including a top hat in town and even a straw boater during the summer months. *(JC)*

First published 2012

Amberley Publishing
The Hill, Stroud
Gloucestershire, GL5 4EP

www.amberley-books.com

British Library Cataloguing in Publication Data. A catalogue record for this book is available from the British Library.

ISBN 978 1 4456 0354 4

Typeset in 9.5pt on 12pt Celeste.
Typesetting by Amberley Publishing.
Printed in the UK.

had no idea that they were to be so many and the narrative jumps backwards and forwards in time. We do have some fixed points. For example, in the opening chapter of *A Study in Scarlet* we learn that Watson and Holmes first met in 1881 and subsequently agreed to share accommodation at 221B Baker Street. Later, in *His Last Bow*, we discover something of Holmes's war service at the outbreak of the First World War. Therefore the accounts of his association with Watson span a period of roughly thirty-three years from 1881 up to 1914, with the majority of the cases concentrated within the last two decades of the nineteenth century, although there are also references to earlier ones.

This was a time of great upheaval within London and British society as a whole. The city had grown tremendously quickly during the nineteenth century and the result was a rich mix of mansions and slums existing almost cheek-by-jowl in some parts. It was a time that saw the emergence of a new middle class, and to add colour to the palette the busy docks brought a steady stream of exotic characters from all over the Empire. In terms of technological change this period, spanning the turn of the century, saw a string of modern inventions coming to the fore; electricity and telephones certainly, but also a revolution in transportation which saw the horse-drawn vehicles give way to motor cars and buses. In London the Underground, which had first opened with the Metropolitan Railway in 1863, grew in leaps and bounds thanks to the introduction of electrification. Following on from the rise of the railways in the mid-nineteenth century, these changes in personal transportation brought a degree of freedom and accessibility to the city never seen before. Instead of living in central London, a new breed of commuters surged in and out from the suburbs or even beyond the city boundaries like a tide of humanity.

For inclusion in this guide, the locations have to be mentioned in the original stories by name – no inference or supposition permitted – although references to 221B Baker Street are not included as they are far too numerous. Statistically *The Adventure of the Greek Interpreter* has the highest number of entries, fourteen in all, while *The Hound of the Baskervilles* comes a close second with thirteen. That in itself might seem surprising, as you would be forgiven for thinking that the action took place on the moors, but this is the longest of the Sherlock Holmes adventures and London does keep cropping up. At the other extreme there are a handful of stories with no specific references to London locations. I will leave it to your own powers of deduction to work out which ones, but the index at the back of this book might help.

The geographical spread of the locations is interesting with a good smattering in central London, as to be expected, but further out into the

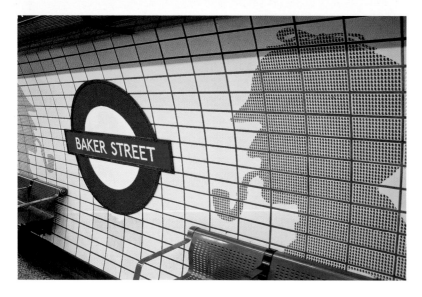

Above: Tiling at Baker Street Underground Station. Each tile consists of dozens of tiny Sherlocks.

suburbs the choices largely reflect Conan Doyle's personal knowledge of the districts concerned. For example, south London scores very highly – he had a home in South Norwood – whereas north London is hardly represented at all. Accordingly, this survey of Holmesian London divides the city into only four sections, Central, West, South and East – with those in the north split between the West and East.

In many cases Conan Doyle refers to very specific places, although there are some notable absentees. Where, for example, is St Paul's Cathedral or Tower Bridge? (The latter only gained Holmesian associations thanks to the more recent Hollywood films starring Robert Downy Jnr) Otherwise he tends to be quite vague and, sometimes, a little loose with his geography. Holmes, of course, has an encyclopedic knowledge of London. But why does he leave for Dartmoor from Paddington Station and return via Victoria? Many of the locations are largely unchanged since 1900, while others have disappeared under the march of redevelopment. But that is part of the appeal of a great city like London. It is a rich mix of the old and the new, forever rebuilding itself anew. Perhaps the most remarkable aspect of the Sherlock Holmes stories is that they have survived the changes to be rediscovered by successive generations.

Of course Sherlock Holmes's cases weren't confined to the metropolis and many of his adventures took him to other parts of the country and overseas. But that is probably the basis of another book, and for now there is a very big and exciting city waiting to be explored. 'Come, Watson come! The game is afoot!'

Central London

'The day had been a dreary one, and a dense drizzly fog lay low upon the great city. Mud-coloured clouds drooped sadly over the muddy streets. Down the Strand the lamps were misty splotches of diffused light, which threw a feeble circular glimmer upon the slimy pavement. The yellow glare from the shop-windows streamed out into the steamy, vaporous air, and threw a murky, shifting radiance across the crowded thoroughfare. There was, to my mind, something eerie and ghost-like in the endless procession of faces which flitted from the gloom into the light, and so back into the gloom once more.'

The Sign of Four

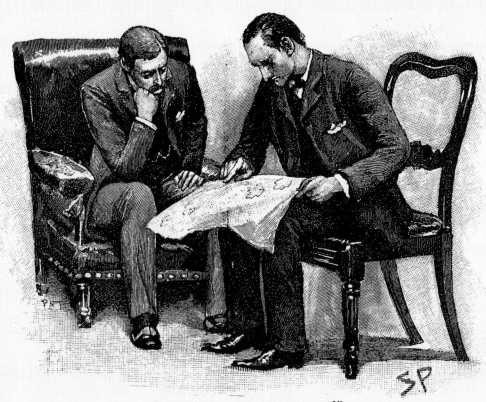

"WHAT DO YOU MAKE OF THAT?"

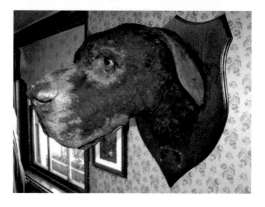

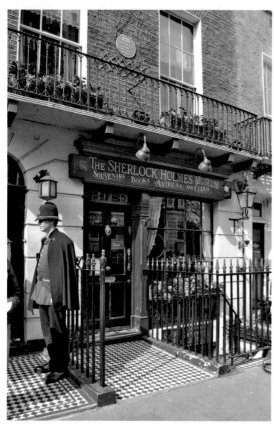

Above: The Hound, 'Killed 19th October 1888', stuffed and mounted. (*Ell Brown*)

Left: The Sherlock Holmes Museum at 221B Baker Street. (*JC*)

Below: Reconstruction of the famous sitting room, packed with references to Holmes's cases. (*Doug Neiner*)

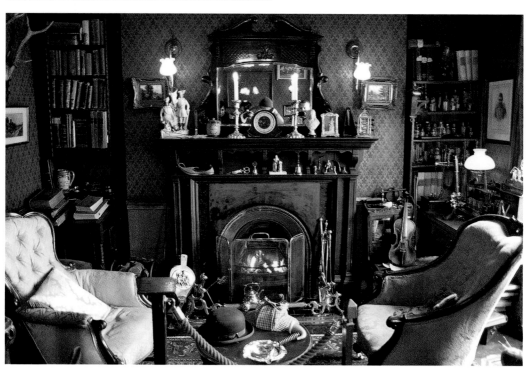

221B Baker Street

'We met next day as he had arranged, and inspected the rooms at No. 221B, Baker Street, of which he had spoken at our meeting. They consisted of a couple of comfortable bedrooms and a single large airy sitting-room, cheerfully furnished, and illuminated by two broad windows. So desirable in every way were the apartments, and so moderate did the terms seem when divided between us, that the bargain was concluded on the spot.'

Dr Watson gives us this description of 221B Baker Street in the first of the Sherlock Holmes stories, *A Study in Scarlet*. Its location has been subject to much speculation but readers are so engrossed by the world of Sherlock Holmes that the attendants at the Sherlock Holmes Museum in Baker Street are frequently asked about its authenticity. (Sorry, but 221B and the characters that inhabited it were fictitious.) When Conan Doyle began writing the stories the terraced houses of Baker Street didn't go beyond No. 100 and he placed 221B in Upper Baker Street to avoid identifying someone's home. The street was only extended later and the site of the museum is as good a candidate for 221B as any. It was granted a change to the out-of-sequence 221B number in 1990. At that time the actual address was covered by the Abbey National's Art Deco office building at 219–229. The building society also sponsored the statue by the Baker Street Underground.

As the Sherlock Holmes adventures unfolded, readers became familiar with the 221B apartment as a backdrop and the cauldron in which new clients revealed their stories and where the excesses of Holmes's behaviour were given full reign. The landlady, Mrs Hudson, was a paragon of patience, putting up with the comings and goings of clients and policemen at all hours of the day, all manner of experiments with chemicals and other substances, and even the time when Holmes decided to use the wall for some indoor target practice. But it is the chemistry between the two men that is at the core of the stories, and Watson generously brushes over his companion's untidiness and mood swings. 'Holmes was certainly not a difficult man to live with,' he recalls. 'He was quiet in his ways, and his habits were regular.'

Baker Street:
- The Sherlock Holmes Museum www.sherlock-holmes.co.uk
- Camden House on Baker Street is where Holmes and Watson stake out 221B from the other side of the road. *The Adventure of the Empty House.*
See also: Baker Street Station on The Underground, p46.

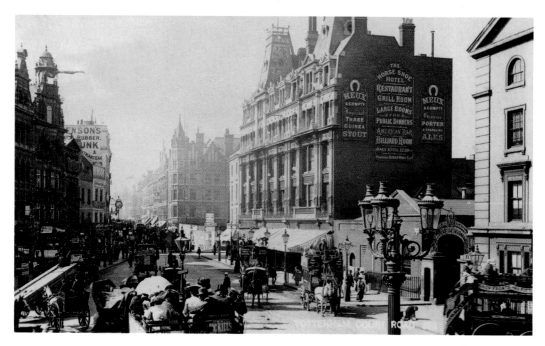

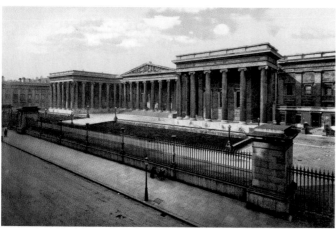

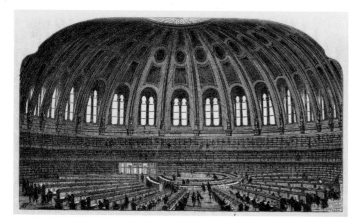

Top: Tottenham Court
Road seen from Oxford
Street. (*CMcC*)

Left: British Museum and
the Round Reading Room.
(*LoC*)

*Above: The Adventure of
the Red Circle.*

Bloomsbury & the British Museum

This is a part of London that Conan Doyle was familiar with and accordingly it is heavily populated with Holmesian activities. The Bloomsbury area is to the south of Euston Road and bordered on either side by Marylebone to the west and St Pancras and Clekenwell to the east. It is home to the University of London and also the British Museum, which was established in 1753 and until 1997 incorporated the British Library in the great Round Reading Room. This is visited by Holmes in *The Adventure of Wisteria Lodge*.

Bloomsbury is dissected vertically by the Tottenham Court Road, where events in *The Adventure of the Blue Carbuncle* began to unfold when the commissionaire Peterson witnessed an unusual attack. 'In front of him he saw, in the gaslight, a tallish man, walking with a slight stagger, and carry a white goose slung over his shoulder. As he reached the corner of Goodge Street, a row broke out between this stranger and a little knot of roughs.' Disturbed by uniformed Paterson, the 'roughs' vanished into the labyrinth of small streets at the back of Tottenham Court Road.

Tottenham Court Road:
- Mrs Sutherland's father is a plumber in TCR. *A Case of Identity*.
- Peterson, the Commissionaire, is making his way home on TCR when he sees a man carrying a white goose being attacked near the corner of Goodge Street. *The Adventure of the Blue Carbuncle*.
- Holmes recounts how he purchased his Stradivarius violin at a 'Jew's broker' in TCR for the bargain price of 55 shillings. *The Adventure of the Cardboard Box*.
- Mr Warren works as a time-keeper at Morton & Waylights. *The Adventure of the Red Circle*.

The British Museum:
- Holmes undertakes research at the British Museum. *The Adventure of Wisteria Lodge*.

Bloomsbury area:
- The Alpha Inn, identified as being near to the British Museum and on one of the roads leading to Holborn, is where Henry Baker and the Goose Club meet. Holmes and Watson go there to investigate. *The Adventure of the Blue Carbuncle*.
- 226 Gordon Square. Lodgings of Francis Moulton, Hatty Doran's true husband. *The Adventure of the Noble Bachelor*.
- Hilton Cubitt meets Elsie Patrick when he stays at the house where she is boarding. *The Adventure of the Dancing Men*.

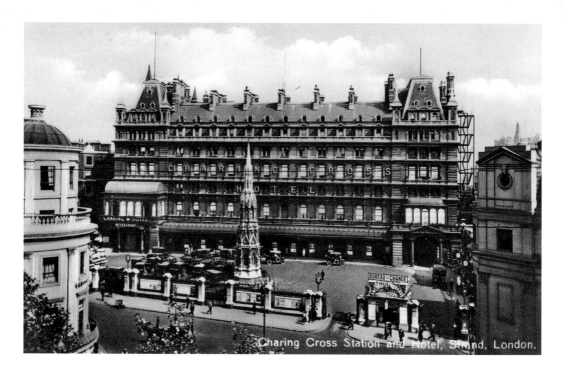

Above: Charing Cross Station was built on the site of the former Hungerford Market and opened in 1864.
Below: A busy station interior in 1908, and a flower seller in Villiers Street. (*LoC*)

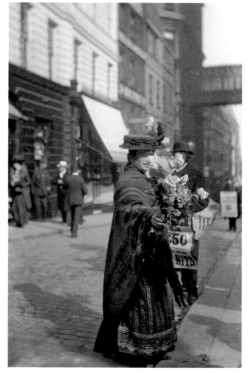

Charing Cross

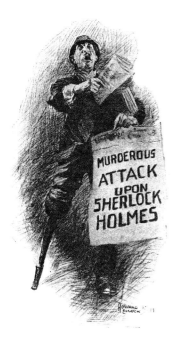

Charing Cross is often cited as being the centre of London, a datum point from which all distances are measured. Charing Cross Road was named after the railway station which was built on the site of the former Hungerford Market and opened in 1864. The cross in front of the station is a Victorian replacement for the Eleanor Cross which once stood here.

Charing Cross Station:
- Irene Adler departs on the 5.15 train for the Continent. *A Scandal in Bohemia.*
- Holmes and Watson take the train for Abbey Grange in Kent. They also catch a cab to here, and send a telegram before returning to Baker Street. *The Adventure of Abbey Grange.*
- Mr Melas sets off from here on his disorientating ride to Latimer's house. *The Adventure of the Greek Interpreter.*
- Holmes states that a man called Mathews knocked out his left canine tooth in the waiting room. *The Adventure of the Empty House.*
- Stanley Hopkins returns here from Yoxley on the last train. Holmes and Watson travel from the station to Chatham. *The Adventure of the Golden Pince-Nez.*
- A woman matching the description of Mme Fournaye is seen here. *The Adventure of the Second Stain.*
- Scott Eccles sends a telegram to Holmes from Charing Cross. *The Adventure of Wisteria Lodge.*
- The Charing Cross Hotel is where Holmes lures the foreign agent Oberstein into a trap. *The Adventure of the Bruce-Partington Plans.*
- Watson sees a one-legged newspaper seller's placard announcing the attack on Holmes. *The Adventure of the Illustrious Client.*

Charing Cross area:
- Watson keeps his memoirs in a tin dispatch-box in the vaults of the Cox & Co. bank. *The Problem of Thor Bridge.*
- The Mexborough Private Hotel, Craven Street, is where Stapleton and his wife stayed while following Baskerville. *The Hound of the Baskervilles.*

Northumberland Avenue:
- Location of hotel where Francis Moulton stayed. *The Adventure of the Noble Bachelor.*
- Mr Melas, the interpreter, makes his money attending to 'wealthy Orientals' staying in the hotels in Northumberland Avenue. *The Adventure of the Greek Interpreter.*

- Holmes and Watson like to visit the Turkish baths. *The Adventure of the Illustrious Client.*

The Northumberland Arms, Sherlock Holmes Pub:

- Sir Henry Baskerville stays at the Northumberland Arms in Northumberland Avenue, Charing Cross. *The Hound of the Baskervilles.* It is now the Sherlock Holmes Pub and houses a collection of Sherlock artefacts and a recreation of the sitting room at Baker Street. This was put together by the brewery from an exhibition put shown at the 1951 Festival of Britain. See also: Charing Cross Hospital – p25.

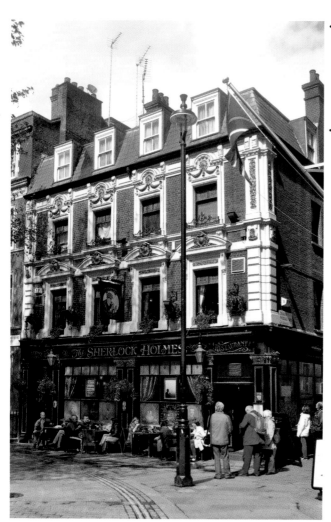

Left: The Sherlock Holmes Pub is in Northumberland Avenue beside the railway station. (*JC*)
Below: A stereoscopic card showing the Victoria Embankment, which was started in 1865 and completed five years later. (*LoC*)

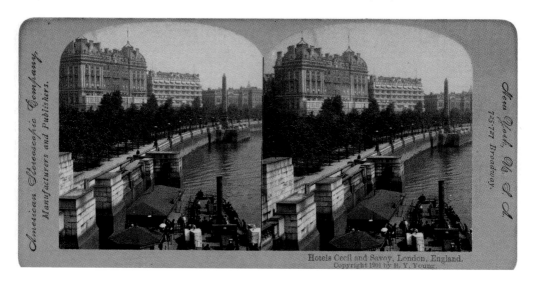

Hotels Cecil and Savoy, London, England.
Copyright 1901 by B. Y. Young.

The City

The City of London is the area defined by the old Roman walls and had become synonymous with the banking and financial sectors even in Sherlock Holmes's time. Hence we find numerous references to banking concerns and stockbrokers as well as a shipping company and tea-brokers. The notable exception is Hugh Boone – the man with the twisted lip – the alias of Neville St Clair, who discovers that he can make a comfortable living posing as a beggar on Threadneedle Street. This is the main road running between the Bank of England – sometimes known as the 'Old Lady of Threadneedle Street' – and the London Stock Exchange. 'Here it is,' observes Holmes, 'that the creature takes his daily seat, cross-legged, with his tiny stock of matches on his lap, and as he is a piteous spectacle a small rain of charity descends into the greasy leather cap which lies on the pavement beside him.' It was common practice for beggars to offer some token item of merchandise such as matches to avoid attracting the hostility of the police.

The City:
• Hugh Boone is to be found begging on Threadneedle Street. The

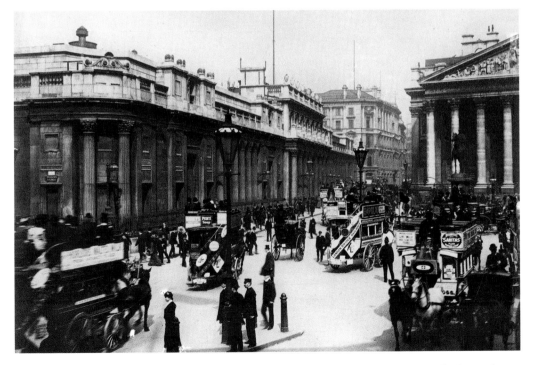

Looking towards Threadneedle Street with the Bank of England on the left. Note the horse-drawn omnibuses. (*LoC*)

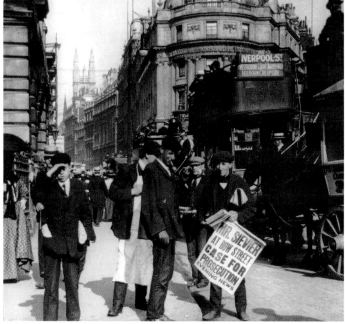

Above Left: Cheapside, which connects with Threadneedle Street.

Left: Newspaper sellers on Cornhill, Royal Exchange. (*LoC*)

Opposite: Cannon Street Station, between Southwark and London Bridge. (*CMcC*)

Aberdeen Shipping Company is located in Freno Street, which branches out of Upper Swandam Lane (fictitious). *The Man With the Twisted Lip.*

- Headquarters of Holder & Stevenson, 'the second largest banking concern in the City of London', is on Threadneedle Street. *The Adventure of the Beryl Coronet.*
- James Dodd is a stockbroker on Throgmorton Street. *The Adventure of the Blanched Soldier.*
- Morrison, Morrison & Dodd, whose client is referred to Holmes, is located in Old Jewry. Ferguson & Muirhead tea brokers have premises on Mincing Lane. *The Adventure of the Sussex Vampire.*
- Drapers Gardens, the workplace of Hall Pycroft at Coxon & Woodhouse. He is offered a position at Mawson & Williams, stockbrokers on Lombard Street. Also the scene of a murder and an attempted robbery. *The Adventure of the Stockbroker's Clerk.*
- 17 King Edward Street, near St Paul's, is the fake address of William Morris and turns out to be the premises for an artificial kneecap maker. *The Adventure of the Red Headed-League.*
- Hosmer Angel works as a cashier in an office in Leadenhall Street. *A Case of Identity.*
- 426 Gresham Buildings, Basinghall Street, workplace of John Hector McFarlane in the solicitor's firm of Graham & McFarlane. *The Adventure of the Norwood Builder.*
- Police Inspector Athelney Jones refers to the 'Bishopsgate jewel case'. *The Sign of Four.*
 Cannon Street Station:
- Neville St Clair returns home every night on the 5.14 from Cannon Street Station. *The Man with the Twisted Lip.*

Clerkenwell

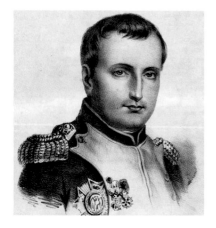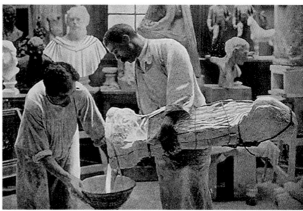

Above: Just one Napoleon, and plaster being poured into a mould.

> 'We have an inspector who makes a speciality of Saffron Hill and the Italian quarter. Well, this dead man had some Catholic emblem round his neck, and that, along with his colour, made me think he was from the South.'
> A somewhat politically incorrect Inspector Lestrade in *The Adventure of the Six Napoleons*

Clerkenwell was known as 'Little Italy' because of the large number of Italians living in the area by the latter half of the nineteenth century. What had once been a fashionable residential area was transformed by the Industrial Revolution into a centre for brewing, printing and other trades. The Aldersgate Street Station, on the Hammersmith & City and Metropolitan underground lines, was renamed as Barbican in 1968 – see p46.

Saffron Hill is the name of a street just to the west of Farringdon Road, on the edge of Clerkenwell. In *Oliver Twist*, published in 1837, Charles Dickens portrays it as a squalid neighbourhood and a 'dirty and wretched' place where Fagin has his den.

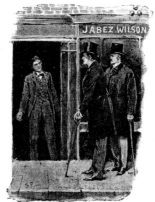

Clerkenwell:
- The Italian quarter in Saffron Hill is noted as the speciality of an Inspector Hill. *The Adventure of the Six Napoleons*.
- Fictitious address for the premises of Jabez Wilson's pawnbrokers business, a short walk from Aldersgate Underground Station. *The Red Headed League*.

"THE DOOR WAS INSTANTLY OPENED."

Covent Garden

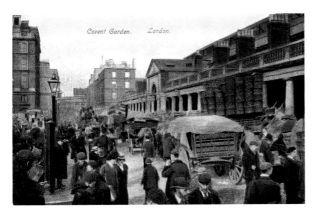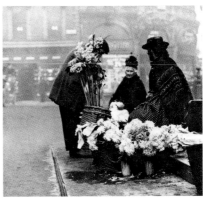

Above: Covent Garden's Fruit and Vegetable Market, and flower sellers. (*LoC*)

'We passed across Holborn, down Endell Street, and so through a zig-zag of slums to Covent Garden Market. One of the largest stalls bore the name of Beckinridge upon it, and the proprietor, a horsey-looking man, with a sharp face and trim side-whiskers, was helping a boy to put up the shutters.'
The Adventure of the Blue Carbuncle.

Watson's reference to the slums comes as a surprise to anyone familiar with the modern and fashionable Covent Garden, but it is a poignant reminder of how these disparate aspects of London life once existed side by side. The square was created in the 1630s by Inigo Jones for the Earl of Bedford as an open piazza enclosed by three terraces of fine houses. Today it is famous for the former market and the opera house. An open fruit and vegetable market had developed within the square by the mid-seventeenth century and in 1830 a more permanent market hall was erected. The Royal Opera House dates back to 1732 and the current building, designed by Edward Barry and completed in 1858, was extensively refurbished in the 1990s.

Covent Garden:
- Beckinridge's stall, from where the birds are sold on to the Goose Club, is in Covent Garden Market. *The Adventure of the Blue Carbuncle.*
- Holmes suggests catching a Wagner second act at the Opera House. *The Adventure of the Red Circle.*

High Holborn:
- Premises of Marx & Co., clothing firm which had supplied clothing to Garcia. *The Adventure of Wisteria Lodge.*

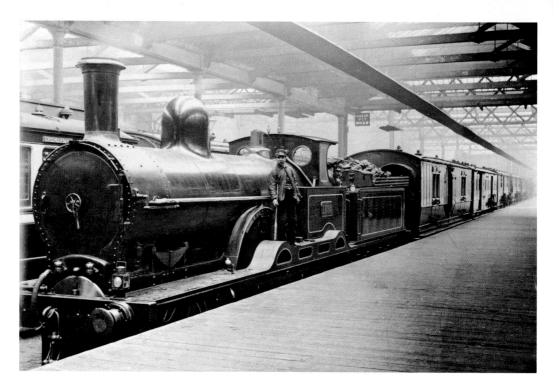

Above: Euston Station and *Archimedes,* a Dreadnought class locomotive built in Crewe in 1886. (*LoC*)
Below: The famous Euston Arch, technically a propylaeum, famously demolished in the 1960s.

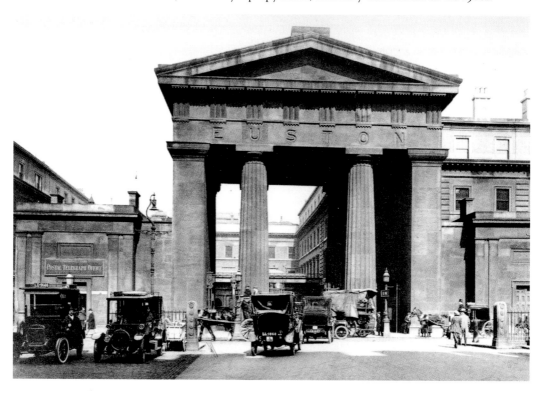

Euston

Euston Station was the earliest London terminus for an inter-city railway when it opened in 1837 to serve Robert Stephenson's London & Birmingham Railway. The first train carriages were hauled up the mile-long Primrose Hill incline by an 'endless rope', a continuous cable wound by stationary steam engines located on the edge of the goods yard in Camden, and once there they would be attached to a conventional locomotive. That system was soon abandoned as the locos became sufficiently powerful, and in the 1870s the station underwent considerable enlargement and modification under the ownership of the London & North Western Railway. This included building the impressive Great Hall, 125 feet long and 62 feet from floor to elaborately corbelled and coffered ceiling, designed by Philip Charles Hardwick. In the 1923 re-grouping of Britain's independent railways into the 'Big Four' regional companies, Euston became the flagship terminal of the London, Midland & Scottish Railway. Unfortunately, nothing of the Victorian railway station that Holmes would have known has survived, as along with Euston's ornamental arch it was demolished in the 1960s. The current Euston is a grim imitation of a municipal bus station and only the twin gate lodges, added in the 1870s to mark the enlarged entrance avenue off Euston Road, remind us of former glories.

Euston Station:
- Enoch J. Drebber and his secretary Joseph Stangerson are last seen at Euston having missed the 9.15 train to Liverpool. Halliway's Private Hotel is on Little George Street, a fictitious location in the Euston area where Joseph Stangerson is murdered. *A Study in Scarlet*.
- Holmes and Watson travel by train to the Peak District. *The Adventure of the Priory School*.
- Holmes takes a train to Tuxbury Old Park, near Bedford. *The Adventure of the Blanched Soldier*.

Euston Road:
- The Church of St Monica, Euston Road, was the fictitious church where Godfrey Norton marries Irene Adler with Holmes, in disguise, acting as the best man. *A Scandal in Bohemia*.

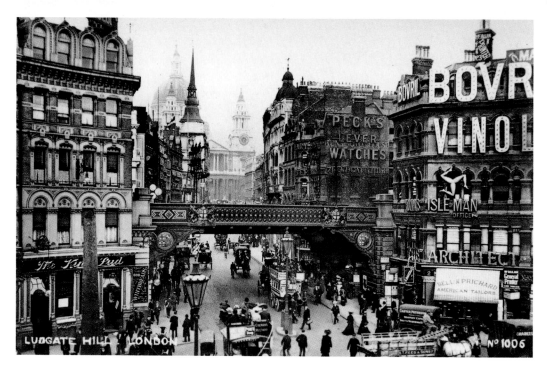

Above: The view from Fleet Street looking up Ludgate Hill towards St Paul's, *c.* 1905.
Below: A London 'Bobby' on traffic duty. (*CmcC*) Long gone, *The News of the World* offices in Fleet Street. (*LoC*)

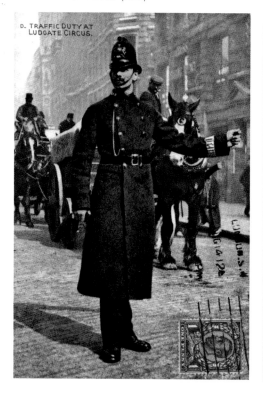

Fleet Street

Fleet Street derives its name from the River Fleet which, until the nineteenth century, ran through the area but is now funnelled underground. Fleet Street is part of the old commercial route going from Westminster to the City of London – the boundary marked by the former location of the Temple Bar gateway – as a continuation of The Strand going eastwards until it joins with Ludgate Hill.

This was London's centre for newspaper publishing until the 1980s, when almost all of the publishers migrated to newer premises elsewhere. Even so, the term 'Fleet Street' is still synonymous with the 'gentlemen' of the press. Another notorious inhabitant of Fleet Street was the 'Demon Barber' Sweeney Todd. Despite his habit of slitting the throats of his hapless customers, rhyming slang has seen his name applied to Scotland Yard's Flying Squad. The street was also noted for its many coffee houses. Much of the area was badly damaged in the Blitz, including Sir Christopher Wren's magnificent St Brides which is otherwise known as the 'Wedding Cake' church, partly because of the bridal connection in the name but also because its tall steeple looks like a wedding cake.

Farringdon Road, the A201, runs northwards at the junction of Fleet Street and Ludgate Hill. The Royal College of Surgeons is to the north of Fleet Street in Loncoln's Inn Fields.

Fleet Street and Temple:
- Holmes and Watson take a three-hour evening stroll along Fleet Street and the Strand. *The Adventure of the Resident Patient.*
- Holmes and Watson go to the *Daily Telegraph* offices on Fleet Street. *The Adventure of the Bruce-Partington Plans.*
- Offices of The Red-Headed League are at Pope's Court, Fleet Street. *The Red-Headed League.*
- Godfrey Norton has lodgings at Inner Temple. *A Scandal in Bohemia.*

Farringdon Street:
- Holmes and Watson travel with Merryweather in a Hansom along Farringdon Street to the bank backing onto Saxe-Coburg Square. *The Red-Headed League.*

Royal College of Surgeons:
- Dr Mortimer spends a little time at the Museum of the Royal College of Surgeons before taking a look 'at the folk in the park'. *The Hound of the Baskervilles.*

The Hansom Cab

Fast and reliable transport is an essential element in any action-packed detective yarn and in its day the one-horsepower Hansom Cab was the Victorian/Edwardian investigative detective's equivalent of Gene Hunt's Ford Granada (although maybe not his red 1983 Audi Quattro). The nimble Hansom Cabs were the perfect chase vehicles to weave through the crowded London streets in Sherlock Holmes's times. For a start they were everywhere and usually available at the wave of a hand, so no pauses in the action while our heroes waited to catch a bus or searched for their Oyster Cards. Furthermore they were virtually identical to the untrained eye and would generally pass unnoticed. This is a real bonus for sleuth or villain alike as their occupants could remain hidden from prying eyes. The Hansom Cab – note definitely not a 'handsome' cab – takes its name from Joseph Hansom, who patented the design in 1834. He successfully combined speed with safety, thanks to a very low centre of gravity, in a lightweight vehicle that could be drawn by a single horse. A Hansom Cab could accommodate two passengers, three at a pinch, who were protected from the elements or mud splashes by a pair of low doors at the front. Later versions had glass windows above the doors to fully enclose the passengers. Instructions were relayed via a small trap door in the roof to the driver, who sat in a sprung seat behind the cab.

There are far too many references to Hansom Cabs throughout the Sherlock Holmes canon to list individually, but note that more conventional 'four-wheelers', with the cabman sitting at the front, were sometimes used as an alternative means of transport.

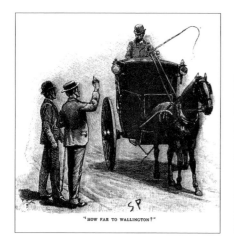

"HOW FAR TO WALLINGTON?"

Above left: Holmes and Watson hail a Hansom Cab, *The Adventure of the Cardboard Box.*
Above right: A four-wheeler in Great Orme Street, *The Adventure of the Red Circle.*

Hospitals

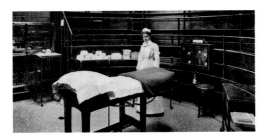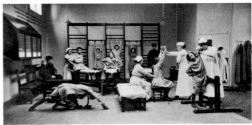

A Victorian operating theatre, and the gymnasium at King's. (*CMcC*)

Watson meets Holmes in a hospital, Barts, but given the frequency of the murders and assaults that take place in their world it is perhaps surprising that hospitals don't feature more often. This is because Conan Doyle cast the Watson character as a doctor, thereby ensuring that expert medical advice was always on hand. Watson outlines his medical background in the opening passage of the very first Sherlock Holmes story, *A Study in Scarlet*:

> 'In the year 1878 I took my degree of Doctor of Medicine of the University of London, and proceeded to Netley to go through the course prescribed for surgeons in the army. Having completed my studies there, I was duly attached to the Fifth Northumberland Fusiliers as Assistant Surgeon. The regiment was stationed in India at the time, and before I could join it, the second Afghan war had broken out.'

Wounded at the Battle of Maiwand in 1880, he returns to England, meeting Holmes in 1881.

Barts (St Bartholomew's) Hospital:
- Located near St Paul's Cathedral, St Barts is where Stamford introduces Watson to Holmes. Stamford and Watson worked there previously. *A Study in Scarlet.*

Charing Cross Hospital:
- Holmes is carried to Charing Cross Hospital following the attack outside the Café Royal. *The Adventure of the Illustrious Client.*
- Dr James Mortimer was a house surgeon at the hospital from 1882 to 1884. *The Hound of the Baskervilles.*

King's College Hospital:
- Located in Camberwell, this is where Dr Percy Trevelyan took a position to research the pathology of catalepsy. *The Adventure of the Resident Patient.*

King's Cross

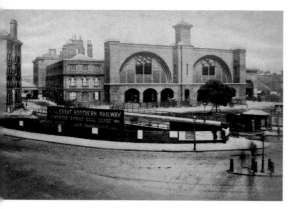

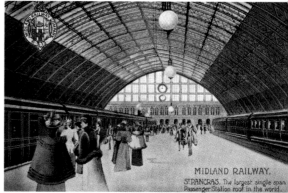

MIDLAND RAILWAY.
ST PANCRAS. The largest single span
Passenger Station roof in the world.

King's Cross is one of London's later railway termini and although it opened in 1852, the station still pre-dates its far showier neighbour, St Pancras, by sixteen years. King's Cross was designed by Lewis Cubitt in a no-frills functional style that sits well with modern attitudes to architectural honesty. You can still enjoy St Pancras, in particular the hotel that forms the frontage on to Euston Road, for what it is, an exuberant celebration of the Victorian taste for high Gothic, but King's Cross has integrity. And while it might never be a beautiful swan, the recent refurbishment and new modern concourse area has revealed a very sparkly duckling. Major railway stations become the natural focal point for any area and often lend their name to the general locality, but strictly speaking both King's Cross and St Pancras are within the Borough of Camden.

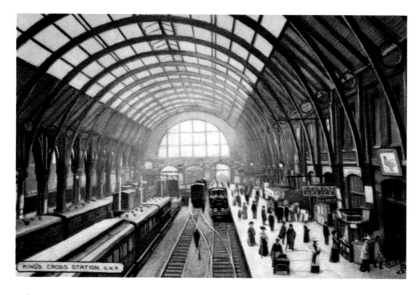

KING'S CROSS STATION. G.N.R.

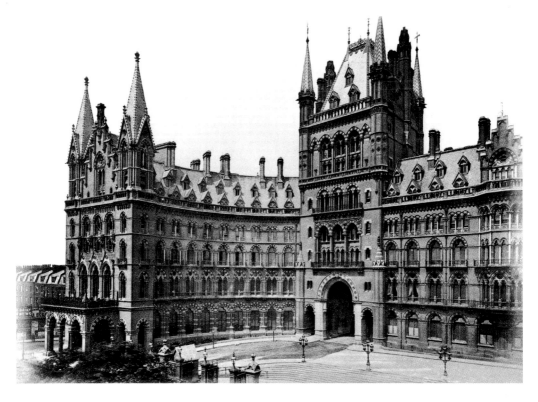

Above: The exterior of the Midland Railway Hotel at St Pancras.
Opposite page, top: An early photograph of the exterior of King's Cross, and interior of Barlow's St Pancras train shed. *Bottom:* The more modest King's Cross interior.

King's Cross Station:
- Holmes and Watson depart from King's Cross Station for Cambridge in search of Godfrey Staunton. *The Adventure of the Missing Three Quarter.*

King's Cross and St Pancras area:
- St Saviour's, near King's Cross, a fictitious church and site of the planned wedding between Hosmer Angel and Mary Sutherland, and then afterwards to the St Pancras Hotel for breakfast. *A Case of Identity.*
- The Gray's Inn Road is on the route to King's Cross Station. *The Adventure of the Missing Three-Quarter.*
- Holmes refers to the St Pancras case in which 'a cap was found beside the dead policeman'. *The Adventure of Shoscombe Old Place.*
- Great Orme Street is the fictitious location of the Warrens' house, described as 'a narrow thoroughfare' at the north-east side of the British Library, with a view down Howe Street. Possibly derived from Great Ormond Street. *The Adventure of the Red Circle.*

Marylebone

More than just a railway terminus, Marylebone is an area within the present City of Westminster roughly defined by Oxford Street to the south, Marylebone Road to the north, the Edgware Road to west and Great Portland Street on the eastern side. The name is thought to have come from the parish church of St Mary built on the bank of the Tybourne, or it may be a corruption of Marie la Bonne, meaning 'Mary the Good'. It is known for the concentration of medical practices in the area, especially around Harley Street. Marylebone Station was a late arrival, opening in 1899 to serve the Great Central Railway's main line into London.

Marylebone:
- The Cavendish Square 'quarter' is noted as a centre for medical specialists by Dr Percy Trevelyan. Holmes and Watson go down Harley Street on their way back from Dr Trevelyan's. *The Adventure of the Resident Patient.*
- Holmes stops the cab on the corner of Cavendish Square when heading back to Baker Street to ensnare Colonel Moran. Manchester Street and Blandford Street are on the route taken by Holmes and Watson on their way to Baker Street. *The Adventure of the Empty House.*
- Dr Moore Agar of Harley Street suggests that Holmes should surrender himself to complete rest. *The Adventure of the Devil's Foot.*
- Holmes refers to Harley Street. *The Adventure of Shoscombe Old Place.*
- Later lodgings of Watson's located here. *The Adventure of the Illustrious Client.*
- Described as the doctors' quarter, Holmes and Watson walk down Wimpole Street, Harley Street and through Wigmore Street on the way to the Alpha Club. *The Adventure of the Blue Carbuncle.*

- Holmes deduces that Watson sent a telegram from the Wigmore Street Post Office. *The Sign of Four.*
- Montague Place, former lodgings of Violet Hunter. *The Adventure of the Copper Beeches.*
- Holmes had rooms in Montague Street, 'just around the corner from the British Museum', for a time when first in London. *The Adventure of the Musgrave Ritual.*
- An attempt on the life of Holmes is made as a horse-drawn van 'furiously driven' almost knocks him down, dashing round Marylebone Lane on the corner of Welbeck and Bentinck Street. Also, possible location of Watson's home as Holmes is described as leaving by 'clambering over the wall which leads into Mortimer Street'. *The Adventure of the Final Problem.*

Edgware Road:
- 136 Little Ryder Street, the fictitious address of Mr Nathan Garrideb. It is described as 'one of the smaller offshoots off the Edgware Road, within a stone-cast of the old Tyburn Tree'. Edgware Road also features as the location of Holloway & Steele, house agent for Garrideb. *The Adventure of the Three Garridebs.*

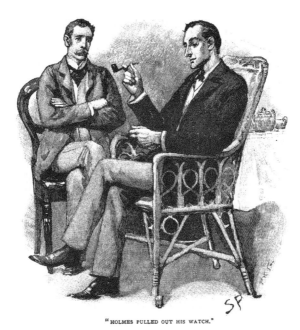

"HOLMES PULLED OUT HIS WATCH."

Opposite page: Departure from Marylebone Station. A phrenology diagram; the Marylebone area is known for its many medical practices.

Mayfair

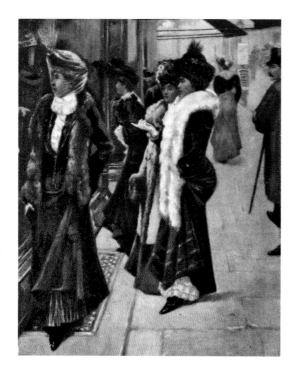

Above: 'Town Life' in Bond Street, postcard *c.* 1905. *Right:* Watson bumps into the old bookseller in *The Adventure of the Empty House.*

Conan Doyle's portrayal of certain areas of London reflects many prevalent preconceptions, and Mayfair in the West End is no exception. Then, as now, it is the location of the smarter exclusive shops, including those on Bond Street, many fashionable galleries, some of the most expensive houses and several of the city's most famous and prestigious hotels. The area is defined to the west by Park Lane on the edge of Hyde Park, on its northern boundary by Oxford Street, Regent Street to the east and Piccadilly to the south. It was originally named after the annual May Fair and the Mayfair name has become synonymous with a luxury lifestyle.

Rents in the area are said to be among the highest anywhere in the world and appropriately Mayfair is the most expensive property on a Monopoly board. Today it is less residential than in Holmes's time and a high proportion of the properties are offices for high-end commercial companies. There are also a number of foreign embassies within Mayfair, including the US Embassy in Grosvenor Square and the Canadian High Commission. The list of prestigious hotels includes Claridge's, The Dorchester and the Grosvenor House Hotel.

Mayfair:

- Bond Street, address of Madame Lesurier, milliner. *The Adventure of Silver Blaze.*
- Holmes and Watson drop into a Bond Street gallery to fill in time. *The Hound of the Baskervilles.*
- 403 Brook Street is the residence of Dr Percy Trevelyan. *The Adventure of the Resident Patient.*
- Martha is ordered to report to Holmes at Claridge's Hotel. *His Last Bow.* J. Neil Gibson stays here. *The Problem of Thor Bridge.*
- Sam Brewer is referred to as 'the well-known Curzon Street money-lender'. *The Adventure of Shoscombe Old Place.*
- 104 Berkeley Square, residence of General de Merville and his daughter, Violet. 369 Half Moon Street, fictitious address for Watson when he poses as Dr Hill Barton. *The Adventure of the Illustrious Client.*
- St George's, Hanover Square, location of marriage between Robert St Simon and Hatty Doran. *The Adventure of the Noble Bachelor.*
- Possible location of Hotel Cosmopolitan, from where the blue carbuncle diamond is stolen. *The Adventure of the Blue Carbuncle.*

Grosvenor Square:

- Scene of a previous case involving a furniture van. *The Adventure of the Noble Bachelor.*
- Isadora Klein lives in one of the 'finest corner houses of the West End'. *The Adventure of the Three Gables.*

Park Lane:

- Watson strolls across Hyde Park and on the corner at the Oxford Street end of Park Lane he bumps into the old bookseller. The Honourable Ronald Adair is murdered at the second floor window of his home, 427 Park Lane. Also mention of 'this very remarkable Park Lane mystery'. *The Adventure of the Empty House.*

The Omnibus

The omnibus was such a common feature of London's streets that it is surprising it doesn't feature in the stories more often. Horse-drawn buses had been in operation since 1829, when George Schilliber launched his pioneering service on the New Road, later renamed as Euston Road. Imitators soon followed and the ensuing chaos caused by competing companies all vying for the same customers resulted in greater regulation. The London General Omnibus Company emerged as the main player and in 1912 the LGOC was bought by the Underground Group and this became the basis of London Transport, formed in 1933. Holmes's period encompasses the introduction of motor buses in the early 1900s, and London buses began turning red in 1907 when the LGOC adopted the colour scheme for its vehicles.

London omnibus:
- Lord Mount-James travels on the Bayswater bus to see Holmes. *The Adventure of the Missing Three-Quarter.*
- According to the *Daily Gazette*, a lady fainted on the Brixton bus. *The Adventure of the Red Circle.*

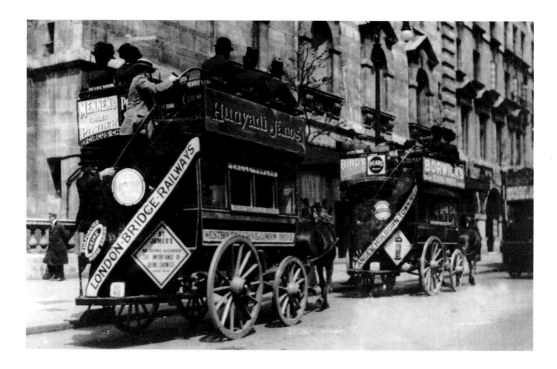

A pair of London's horse-drawn omnibuses. (*LoC*)

Oxford Street

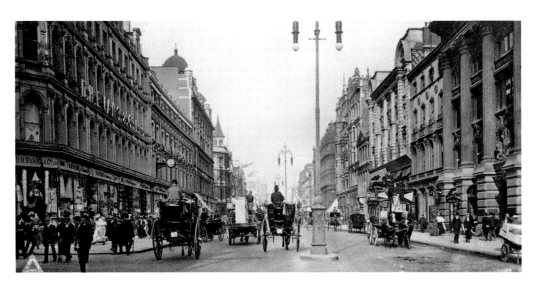

Above: London's longest and busiest shopping street, *c.* 1900.

Crowded with shoppers and choked by an endless stream of buses, there is much about London's premier retail street that has little changed since Holmes and Watson knew it. No doubt due to its junction with Baker Street, Oxford Street is one of the most mentioned thoroughfares in the Sherlock Holmes stories. It follows the route of an arrow-straight Roman road and later became the main route to Oxford. As London expanded, it formed the boundary between Marylebone to the north and Mayfair to the south – both areas of intense Holmesian activity – and intersects with numerous important roads, including Regent Street at Oxford Circus, Charing Cross Road, Tottenham Court Road, New Bond Street and, at the western end, leads onto Park Lane, Bayswater and via Marble Arch to Hyde Park. Oxford Street is 1.5 miles long and has approximately 300 shops, making it the busiest shopping street in Europe. These include a number of flagship stores, including Selfridges which opened in 1909 and is the second largest shop in the UK. Retail heaven or retail hell?

Oxford Street:
- Watson walks through Oxford Street on the way to Baker Street. *The Red-Headed League.*
- Holmes and Watson walk 'into' Oxford Street on their way to the Alpha Club. *The Adventure of the Blue Carbuncle.*
- Holmes and Watson cross Oxford Street on the way home from Dr Trevelyan's. *The Adventure of the Resident Patient.*

- Part of the circuitous route on which Harold Latimer takes Mr Melas to his home. *The Adventure of the Greek Interpreter.*
- Holmes goes here on 'some business', but on the corner of Welbeck Street a horse-drawn van tries to run him down. A second attempt is made to kill Holmes when a brick hurtles down from the roof of one of the houses on Vere Street, off Oxford Street. *The Adventure of the Final Problem.*
- Real location of the Capital & Counties Bank, Oxford Street, where Holmes has an account. *The Adventure of the Priory School.*
- Holmes and Watson follow Dr Mortimer and Sir Henry Baskerville on foot along Oxford Street and down Regent Street. Later, Holmes finds one of Watson's cigarette stubs with tell-tale markings for the tobacconists Bradley of Oxford Street. *The Hound of the Baskervilles.*
- Holmes and Watson catch a Hansom Cab from here to Hampstead. They also recognise a photograph of Milverton's killer in the window of an Oxford Street store near 'Regent Circus', which was an alternative name for Oxford Circus. *The Adventure of Charles Augustus Milverton.*
- Watson bought a pair of boots from Latimers, Oxford Street. *The Disappearance of Lady Frances Carfax.*

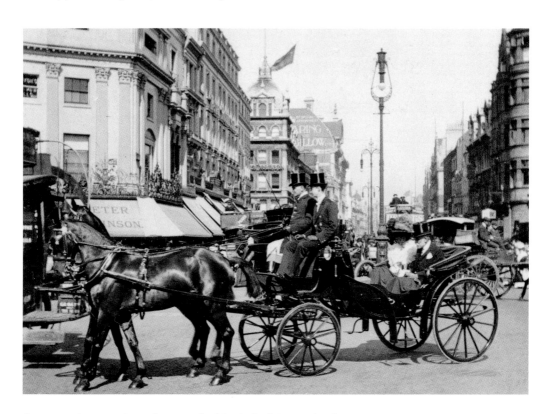

A smart private carriage photographed in Oxford Street. (*LoC*)

Piccadilly Circus

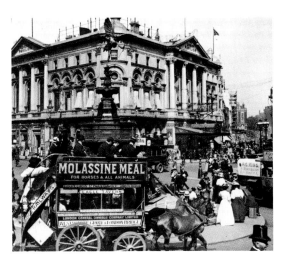

Above: The hustle and bustle of Piccadilly Circus surrounds the statue of Anteros. (*Man Vyi*)

It is said that if you stand in Piccadilly Circus long enough you are sure to meet everyone you know, or, in some versions, in the world. This may be an exaggeration, but it does feels as if you have bumped into every tourist to ever visit London. In Holmesian times there were far fewer tourists, but Piccadilly was still an important hub, both of humanity and of several major thoroughfares – as photographs from around 1900 confirm, with busy scenes of cabs, horse-drawn buses and pedestrians. Leading off from this hub we have Regent Street, Shaftsbury Avenue, Haymarket and Piccadilly itself, and it is only a short walk from both Trafalgar and Leicester squares. Therefore it is all the more surprising that Conan Doyle mentions it on only a couple of occasions. What would Sherlock Holmes recognise of today's PC? The famous statue with bow and arrow for one. Erroneously referred to as Eros, this is actually Anteros, the Greek god of requited love. Cast in aluminium – the fountain is bronze – Alfred Gilbert's sculpture of a naked male figure ruffled Victorian sensibilities when erected in 1893. It was originally positioned in the centre of the circus as a traffic island.

Piccadilly Circus:
- At the Criterion Bar, Watson first learns of Sherlock Holmes from his friend Stamford. *A Study in Scarlet.*
- Shaftsbury Avenue is on the roundabout route Harold Latimer takes to disorientate Mr Lelas. *The Adventure of the Greek Interpreter.*

Policing London

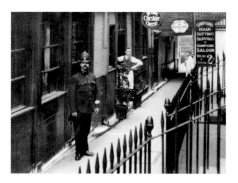

Sherlock Holmes frequently came into contact with the officers of London's Metropolitan Police force. Sometimes he would mock their blunderings and incompetence, even amusing himself by teasing the various inspectors that crossed his path, while at other times consulting detective and police detective would quietly express mutual respect. Several police inspectors make an appearance in the adventures, the most prominent being Inspector Lestrade who develops a long-term working relationship with Holmes. We also meet others, including Gregson, Baynes, Bradstreet, Hopkins and Athelney-Jones.

London's police force had only been in existence since 1829, when the Home Secretary, Robert Peel, had passed the Metropolitan Police Act. Throughout the remainder of the century the new force struggled to cope with the wave of crime that flourished amid the upheaval caused by London's rapid growth, and the brutality and extent of real-life crime far outstripped that portrayed in fiction. It took time for the police to learn correct forensic procedures and it was not uncommon for a victim's body to be whisked away before any examination had been made of the murder scene. It was thanks to Conan Doyle that Holmes always remained ahead of the game.

Scotland Yard and the Metropolitan Police:
- Frequent mentions. Originally located on Whitehall Place, with a rear entrance on Great Scotland Yard, which is how the name came about. A bigger version, New Scotland Yard, was built on the Embankment overlooking the Thames in the 1890s, and in 1967 the Met moved into its current headquarters at 10 Broadway.

Bow Street:
- Holmes takes Watson to Bow Street, where 'the two constables at the door saluted him'. *The Man With the Twisted Lip*.

By arrangement only, visit the Black Museum at New Scotland Yard.

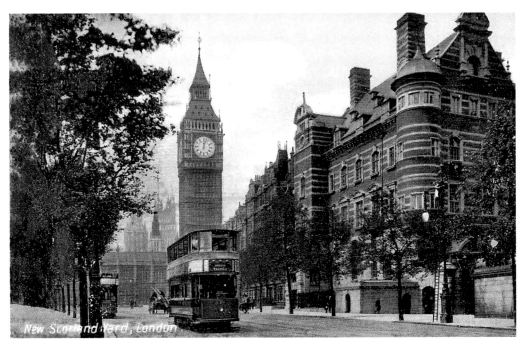

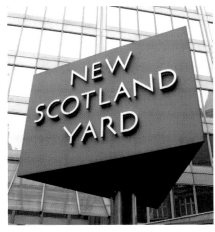

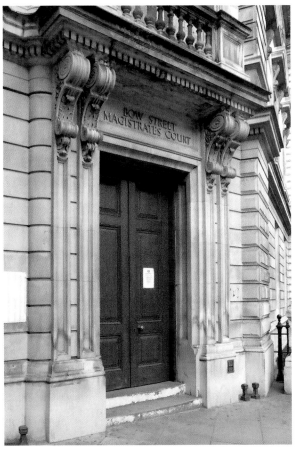

Top: New Scotland Yard overlooking the Embankment, with the Houses of Parliament in the background.

Opposite page: Some of London's finest, the boys in blue. (*LoC/CMcC*)

Above: Revolving sign at the new New Scotland Yard.

Right: Entrance to Bow Street Magistrates Court. (*Mark Hillary*)

Regent Street

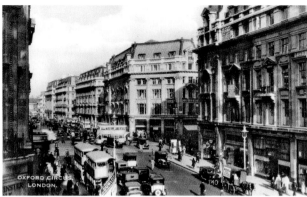

Above: The attack on Sherlock Holmes outside the Café Royal in Regent Street.
Right: Oxford Circus and Regent Street.

> 'We learn with regret that Mr Sherlock Holmes, the well-known private detective, was the victim this morning of a murderous assault which has left him in a precarious position ... The event seems to have occurred about twelve o'clock in Regent Street, outside the Café Royal. The attack was by two men armed with sticks, and Mr Holmes was beaten about the head and body, receiving injuries which the doctors describe as most serious. He was carried to Charing Cross Hospital, and afterwards insisted on being taken to his rooms in Baker Street.'

Aside from squeezing four location references into the one paragraph, this newspaper report, from *The Adventure of the Illustrious Client*, belies Regent Street's reputation as one of the grandest streets in central London. Named after the Prince Regent, later to become George IV, it was one of the first planned developments intended to impose order upon the old street patterns. Linking Regent's Park with Charing Cross, it was built between 1814 and 1825 and originally known as New Street. However, the street we see nowadays is the result of major rebuilding carried out between 1895 and 1927, and south of Oxford Street none of the original buildings survive. Strict rules were imposed on the design of the new buildings, including the use of Portland stone for the façades, giving Regent Street its uniformity of style. This construction work would have been going on throughout Holmes's era, and he would have been familiar with the fashionable Café Royal, which opened at No. 68 in 1865 (it closed in 2008). The present building dates from 1928. The Liberty store opened in 1875 – although its Tudor styling is from the 1920s – and Hamleys toy shop has been on Regent Street since 1906.

Regent Street:

- Premises of Gross & Hankey's jewellers, where Godfrey Norton buys rings for his marriage to Irene Adler. *A Scandal in Bohemia.*
- Holmes and Watson follow Mortimer and Baskerville on foot along Regent Street. *The Hound of the Baskervilles.*
- Holmes and Watson pass through Regent Circus (Oxford Circus) on the way to meet Mycroft at the Diogenes Club. *The Adventure of the Greek Interpreter.*
- Holmes is badly beaten by two men with sticks outside the Café Royal. His assailants escape through the building into Glasshouse Street at the back. *The Adventure of the Illustrious Client.*
- Conduit Street, off Regent Street, is the address for Colonel Sebastian Moran, the would-be assassin of Holmes. *The Adventure of the Empty House.*

Langham Hotel, off Regent Street:

- Captain Morston, the father of Mary Morston, stayed here in 1878. *The Sign of Four.*
- The King of Bohemia stays here under the pseudonym Count Von Kramm. *A Scandal in Bohemia.*
- Lodgings of Philip Green. *The Disappearance of Lady Frances Carfax.*

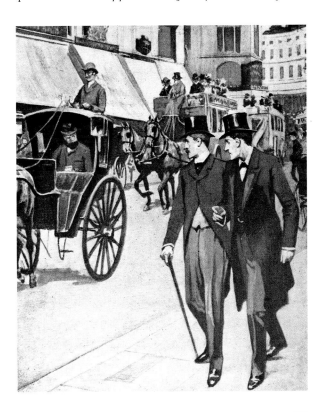

Watson and Holmes in Regent Street
– *The Hound of the Baskervilles.*

St James's & Pall Mall

St James's is a relatively small enclave of the most exclusive kind. Just a hefty stone's throw from Buckingham Palace, it consists of a rectangular area nestling between Green Park and St James's Park on two sides, Piccadilly to the north and Haymarket to the east. At its heart is St James's Square, and sandwiched between Pall Mall and St James's Park are St James's Palace and Clarence House – for many years the home of the Queen Mother – and also Marlborough House.

St James's also happens to be at the epicentre of the secretive and mysterious world of the gentleman's club. In *The Adventure of the Greek Interpreter* Watson is allowed to enter the Diogenes Club, where Sherlock introduces him to his older brother, Mycroft.

'There are many men in London, you know, who, some from shyness, some from misanthropy, have no wish for the company of their fellows,' he explained. 'Yet they are not averse to comfortable chairs and the latest periodicals. It is for the convenience of these that the Diogenes Club was started, and it now contains the most unsociable and un-clubbable men in town. No member is permitted to take the least notice of any other one. Save in the Strangers' Room, no talking is, under any circumstances, permitted, and three offences, if brought to the notice of the committee, render the talker liable to expulsion ... I have myself found it a very soothing atmosphere.'

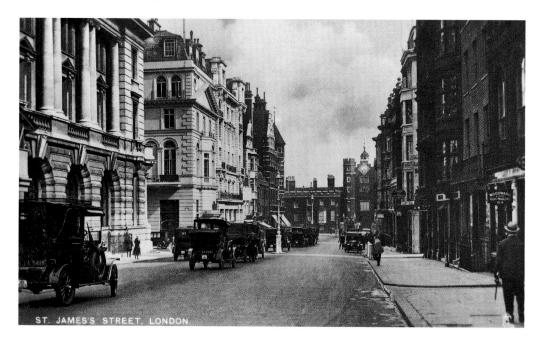

ST. JAMES'S STREET, LONDON.

40

Right: Sherlock's older brother, Mycroft Holmes, is a regular at the Diogenes Club – *The Adventure of the Greek Interpreter.*

St James's and Pall Mall:
- Mycroft Holmes lodges in Pall Mall, and the Diogenes Club is just opposite his rooms. Mr Melas, the interpreter, has lodgings on the floor above Mycroft. *The Adventure of the Greek Interpreter.*
- Holmes takes a cab to Pall Mall and spends the day at Mycroft's lodgings after two attempts on his life. *The Adventure of the Final Problem.*
- Watson is referred to an estate agents in Pall Mall when he makes enquiries regarding Charlington Hall. *The Adventure of the Solitary Cyclist.*
- The shipping office of the Adelaide–Southampton Line stands at the end of Pall Mall. *The Adventure of the Abbey Grange.*
- Watson goes to the London Library in St James's Square to research Chinese ceramics. *The Adventure of the Illustrious Client.*
- Christies, located in King Street since 1823, is one of the two auction houses Nathan Garrideb visits. *The Adventure of the Three Garridebs.* Holmes also refers to Christies. *The Adventure of the Illustrious Client.*

Carlton House Terrace:
- London address of the Duke of Holdernesse. *The Adventure of the Priory School.*
- Baron von Herling refers to Carlton House Terrace as the location of the German Embassy. *His Last Bow.*

The Gentlemen's Clubs:
- Mycroft Holmes is a regular at the Diogenes Club on Pall Mall, described as 'some little distance from the Carlton'. Sherlock takes Watson there to meet him for the first time. *The Adventure of the Greek Interpreter.*
- Sir James Damery belongs to the Carlton Club. *The Adventure of the Illustrious Client.*
- Langdale Pike belongs to a club on St James's Street. *The Adventure of the Three Gables.*

41

The Strand

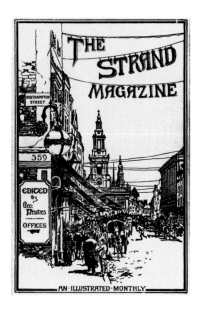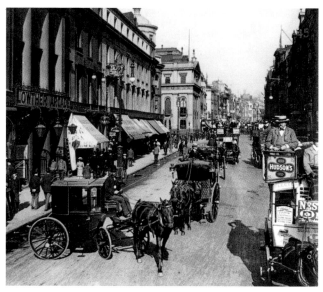

Above: The Sherlock Holmes stories published in *The Strand* recruited a dedicated fan base for Conan Doyle's detective. The Strand, *c.* 1900. (*LoC*)

Judging by the number of mentions, the Strand appears to be one of Holmes's and Watson's favourite haunts. They eat at Simpson's restaurant on more than one occasion and, in *The Adventure of the Resident Patient*, the celebrated Sherlock Holmes illustrator Sydney Paget depicts the duo nonchalantly walking arm in arm. (Shown opposite – and note the absence of deerstalker.)

> 'For three hours we strolled about together, watching the ever-changing kaleidoscope of life as it ebbs and flows through Fleet Street and the Strand. Holmes had shaken off his temporary ill-humour, and his characteristic talk, with its keen observance of detail and subtle power of inference, held me amused and enthralled.'

Starting at Trafalgar Square and heading eastwards to join with Fleet Street, the Strand is another of London's roads with Roman origins. By the Middle Ages it had become an important route between the City and the Palace of Westminster. It was largely rebuilt in the nineteenth century, partly as a result of the construction of the Victoria Embankment in the 1860s, which saw the river bank moved more than 160 feet to the south. It subsequently became a fashionable area with its shops, coffee houses and theatres, and was a centre of Victorian night-life of all sorts. The Strand

was widened in 1900. In the words of the popular song, 'Let's all go down the Strand – Have a banana!'

The Strand:

- Watson stays at a private hotel in the Strand when he first arrives in London and before he is introduced to Holmes. Letters from the Guion Steamship Company are found at the scene of Drebber's murder in Brixton, addressed to the American Exchange in the Strand. *A Study in Scarlet.*
- Holmes and Watson take an evening stroll along the Strand and Fleet Street. *The Adventure of the Resident Patient.*
- Watson is instructed to catch a Hansom Cab from here after dashing down Lowther Arcade to elude Moriaty's cronies. *The Adventure of the Final Problem.*
- Simpson's restaurant, 100 Strand. *The Adventure of the Dying Detective* and *The Adventure of the Illustrious Client.*
- Sir Henry Baskerville buys a new pair of boots in the Strand. *The Hound of the Baskervilles.*
- There is a Strand postmark on the telegram from Cyril Overton at the start of the story, and later on Godfrey Staunton is seen running towards the Strand. *The Adventure of the Missing Three-Quarter.*
- Sotheby's is one of the two auction houses which Nathan Garrideb sometimes visits. The company's main premises were on the Strand until 1917, when they transferred to Bond Street. *The Adventure of the Three Garridebs.*
- Holmes and Watson drive over the river on Waterloo Bridge and up Wellington Street on the way to Bow Street. *The Man With the Twisted Lip.*

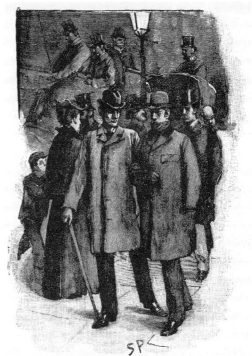

" WE STROLLED ABOUT TOGETHER."

43

Theatres, Concert Halls & Music

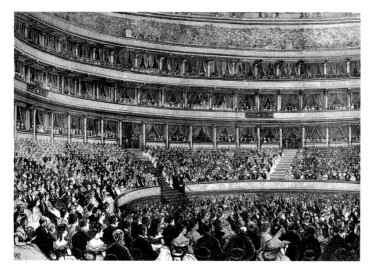

Above: Interior of the Royal Albert Hall, and Holmes 'enwrapped in the music' at St James's Hall. He had a preference for the German composers.

'My friend was an enthusiastic musician, being himself not only a very capable performer, but a composer of no ordinary merit.' So wrote Dr Watson in *The Adventure of the Red-Headed League*. On several occasions, we see how this passion for music was employed by Holmes to sharpen his thoughts or to sooth his mind and spirits. He owned a fine Stradivaius, worth at least five hundred guineas, purchased from a 'Jew broker in Tottenham Court Road for fifty Shillings'.

Haymarket Theatre:
- Josiah Amberley claims to have been at the theatre as his alibi, but Holmes checks the box office charts. *The Adventure of the Retired Colourman.*

Imperial Theatre:
- Violet Smith's father, James Smith, conducted the orchestra at this theatre, now demolished. *The Adventure of the Solitary Cyclist.*

Lyceum Theatre, Wellington Street:
- The theatre is a meeting place for Williams with Mary Morston, as well as Holmes and Watson. *The Sign of Four.*

St James's Hall:
- Concert hall attended by Holmes and Watson. *The Red-Headed League.* See also – The Albert Hall, p55 and Covent Garden, p19.

Trafalgar Square

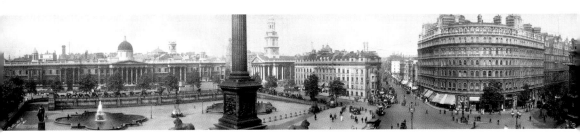

Commemorating the Battle of Trafalgar, London's largest public square was started by John Nash and finished by Sir Charles Barry in 1845. Against Barry's wishes it is dominated by Nelson's impressive column, completed in 1843, although the bronze reliefs were not added until 1854. Landseer's lions arrived in 1867, but the current fountains are post-Holmes designs, produced by Sir Edwin Lutyens in the 1930s.

Trafalgar Square:
- Sharply sarcastic, Holmes suggests that Inspector Lestrade would do just as well to dredge the Trafalgar Square fountains as the Serpentine in his search for Hatty Doran. *The Adventure of the Noble Bachelor*.
- A cab picks up a man posing as a detective in Trafalgar Square. *The Hound of the Baskervilles*.

Above: Panoramic view of Trafalgar Square *c.* 1895, with National Gallery to the left.
Below: Landseer's lions, and a newspaper seller outside the *Grand Hotel*. (*LoC*)

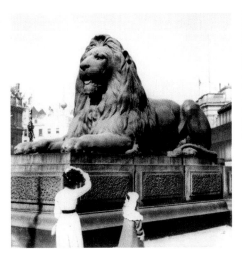

The Underground

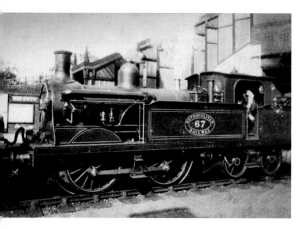

Above: Metropolitan Railway loco No. 67. Baker Street station opened in 1863. (*JC*)

London was the first city in the world to have an underground transportation system. The Metropolitan Railway was opened in 1863 to connect the various railway termini which had been built along the Euston Road on the northern edge of the city. Conveniently for Sherlock Holmes it included a station at Baker Street and the original part of the station has survived virtually intact (now served by the Circle and the Hammersmith & City lines). Although referred to as being underground, the Metropolitan Railway was built using the highly disruptive 'cut and cover' method whereby a deep ditch was dug and then covered over on the surface by a roof structure. Even though gaps were left for ventilation, the atmosphere in the early days of steam locomotion was said to be very bad. The popularity of the underground saw a rapid expansion of the network over the next two decades, with a proliferation of new lines including, by the 1890s, the deeper level 'tube' lines. By the end of the nineteenth century, the network had reached many of the new suburbs mushrooming on the edges of London.

The arrival of the underground was perfectly timed for Sherlock Holmes, and new lines continued to open into the early years of the twentieth century. From 1908 the rival co-operators began to promote a more unified service and the introduction of electrification made travelling a far more pleasant experience. In 1933 all of the municipal and independently run lines were grouped together under the London Passenger Transport Board and this soon became abbreviated to London Transport. The new unified system was represented on the iconic and highly stylised tube map devised by an electrical engineer named Harry

Beck. Uniformity of signage was applied across the network, with the distinctive 'wheel-and-bar' roundel of the London General Omnibus Company. This was adopted for all London Transport operations, above and below ground.

On the Underground:

- Aldersgate Station, now named Barbican. Holmes and Watson take the short walk from here to Jabez Wilson's pawnbrokers shop. *The Red-Headed League.*
- Aldgate Station, the eastern terminus of the Metropolitan Line. The body of Arthur Cadogan West is discovered by the tracks just outside the underground station. Holmes continues his trackside investigation at the Gloucester Road Station in South Kensington as it backs onto Hugo Oberstein's lodgings. *The Adventure of the Bruce-Partington Plans.*
- Baker Street Station on the Metropolitan Line. Alexander Holder, the banker, alights at Baker Street to see Holmes. *The Adventure of the Beryl Coronet.*

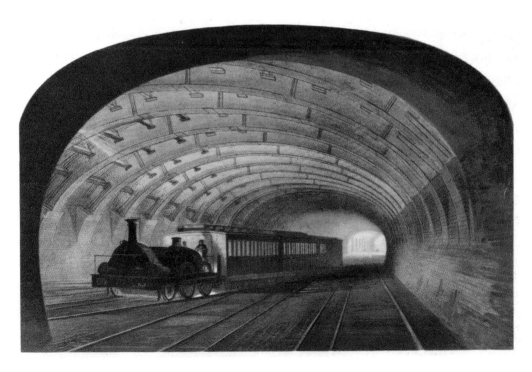

The early underground trains were hauled by steam locomotives, as shown in this 1863 view of the Metropolitan Railway near Paddington.

Victoria

The station at Victoria – note it was named after Victoria Street and not the other way round – is confused. The problem is that it was born with a split personality, as it was originally two totally separate stations built side-by-side. Land to build a station on the north bank of the river was almost impossible to find and in this instance the two stations were constructed on the site of a redundant canal basin. Viewed from the front, the full-on Edwardian baroque stone façade on the left belonged to the South Eastern & Chatham Railway, while the nine-storey mantlepiece-like edifice on the right was the frontage of the Grosvenor Hotel and the entrance for the London Brighton & South Coast Railway station. The two were combined under the 1923 regrouping of Britain's railways, and handed over to the Southern Railway with openings created through the dividing wall.

Victoria Station:
- Confusingly, Holmes and Watson return from Dartmoor by train to Victoria Station, even though their outward journey had been via the GWR at Paddington. *The Adventure of Silver Blaze.*
- After being dumped on Wandsworth Common, Mr Melas catches the last train from Clapham Junction to Victoria. *The Adventure of the Greek Interpreter.*
- Holmes and Watson elude Moriarty by meeting on the Continental Express at Victoria. *The Adventure of the Final Problem.*

Early view of Victoria before the front of the stations was rebuilt.

- Holmes and Watson take a cab to Victoria to catch a train for Birlstone. *The Valley of Fear.*
- Together with Ferguson, Holmes and Watson catch the train to Lamberley. *The Adventure of the Sussex Vampire.*

Victoria Street:

- 16A Victoria Street, the premises of Victor Hatherley, an hydraulics engineer. *The Adventure of the Engineer's Thumb.*

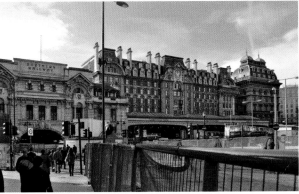

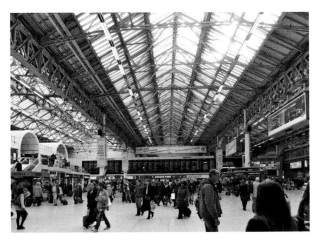

Above: Interior of the SECR station.
Right: Exterior and interior of the LBSCR side of Victoria.

Waterloo Bridge

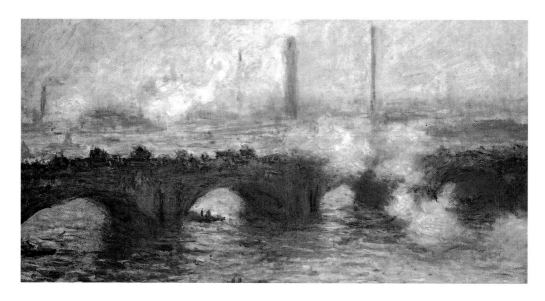

Above: Claude Monet's painting of the old Waterloo Bridge.

Waterloo Bridge connects the Victoria Embankment on the north of the river with the South Bank. As a road and pedestrian bridge it has no connection with the railway station of the same name apart from leading to it. (Trains cross on the Hungerford/Charing Cross Bridge.) The Waterloo Bridge that Holmes and Watson would have been familiar with was designed by the engineer John Rennie and although originally opened in 1817 as a toll bridge, the toll had been abolished by 1878. Both Claude Monet and John Constable thought the bridge notable enough to feature it in their paintings. But by the turn of the century serious settlement meant that a replacement was needed and the current reinforced concrete structure was completed in 1945.

Waterloo Bridge:
- The murderer Jefferson Hope drives his Hansom Cab across Waterloo Bridge. *A Study in Scarlet.*
- Returning from Lee in Kent, Holmes and Watson pass down Waterloo Bridge Road, over the river and then head up Wellington Street to Bow Street to see the beggar Hugh Boone, who is being held on suspicion of murdering Neville St Clair. *The Man With the Twisted Lip.*
- John Openshaw is thrown into the Thames near Waterloo Bridge by the KKK. *The Five Orange Pips.*
 See also – Waterloo Station p82.

Westminster

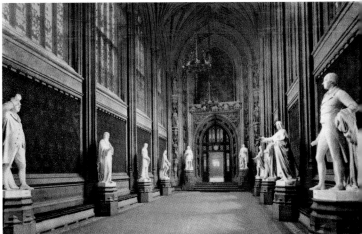

Above: The Palace of Westminster was still relatively new when Holmes and Watson were on the scene.
Below: Westminster Bridge. (*LoC*)

The great Clock Tower rising above the Houses of Parliament has become such an iconic symbol of London, and of Britain, that it is easy to forget that it only dates back to the second half of the nineteenth century. After the old Palace of Westminster burned down in 1834, its replacement was finished in a richly decorative Perpendicular Gothic style contrived by the architect Sir Charles Barry with detailing and furnishing by Augustus Pugin. Both men had died by the time it was eventually completed in 1870, and although

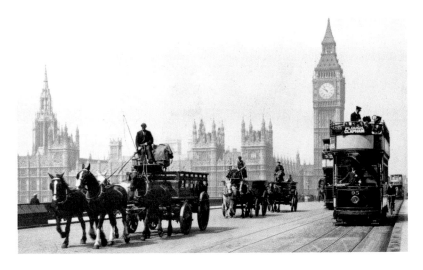

the building has endured their names have not. However, everyone knows the name Big Ben even though, as every schoolchild should tell you, strictly speaking this refers to the largest of the five bells and not to the clock or the tower. The Clock Tower is 316 feet tall – just slightly shorter than the Victoria Tower on the south-western corner – and each clock face is 23 feet in diameter. During the Second World War the Westminster complex was hit by bombs on several occasions and the Victorian Chamber of the House of Commons was rebuilt in the 1950s.

Although the Palace of Westminster contains the two Houses of Parliament, Holmes and Watson are not recorded as ever visiting the building itself. The main seat of power lay within the governmental departments and offices in nearby Whitehall – see p53.

Westminster and the Houses of Parliament:
- Holmes and Watson pass the Houses of Parliament and cross Westminster Bridge on the way to Brixton. *The Disappearance of Lady Frances Carfax.*
- Reference to Morton & Kennedy, the 'famous Westminster electricians'. *The Adventure of the Solitary Cyclist.*
- Holmes and Watson set off from Westminster Stairs in a police launch in pursuit of Jonathan Small in the *Aurora*. Also, Holmes sends a telegram from the Great Peter Street Post Office, Westminster, to the leader of the Baker Street Irregulars. *The Sign of Four.*
- 13 Great George Street, Westminster, is the address of Adolf Meyer, who is on Mycroft's list of foreign agents. *The Adventure of the Bruce-Partington Plans.*

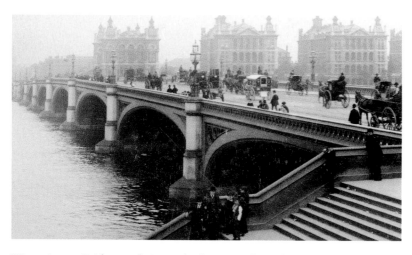

Westminster Bridge and Steps looking southwards across the river to St Thomas's Hospital. (*CUL*)

Whitehall

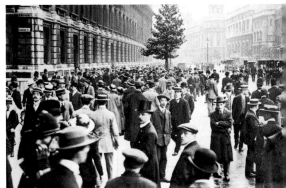

Above: The War Office in Whitehall.
Right: Crowds gather in Whitehall near the entrance to Downing Street. (*LoC*)

Running from Trafalgar Square to Parliament Square, Whitehall has become synonymous with the administration of government. Major departments familiar to Holmes included the War Office, Foreign Office and Downing Street. Note that the term 'Whitehall farce' has nothing to do with politics and comes from the Whitehall Theatre.

Downing Street:
- Holmes and Watson interview Percy Phelps's uncle, the Cabinet Minister Lord Holdhurst, described by Holmes as the 'future Premier of England'. *The Adventure of the Naval Treaty.*

Whitehall:
- Percy Phelps works at the Foreign Office, from where the naval treaty is stolen. Holmes and Watson go there to examine the crime scene. Charles Street is a lane which leads to a side entrance into the Foreign Office. *The Adventure of the Naval Treaty.*
- The Right Honourable Trelawney Hope, Secretary for European Affairs, lives in the fictitious Whitehall Terrace from where the papers are stolen. Also, 16 Godolphin Street is the fictitious address of the murdered Eduardo Lucas. It is described as being between the Abbey and the river, 'almost in the shadow of the Great Tower of the Houses of Parliament'. Also, Whitehall Terrace is said to be only 'a few minutes' walk' from Westminster. *The Adventure of the Second Stain.*
- Mycroft walks from his lodgings in Pall Mall to Whitehall every morning. *The Adventure of the Greek Interpreter.*
- The diamond was taken from Whitehall. *The Adventure of the Mazarin Stone.*

West London

'I had neither kith nor kin in England, and was therefore as free as air – or as free as an income of eleven shillings and sixpence a day will permit a man to be. Under such circumstances I naturally gravitated to London, that great cesspool into which all the loungers and idlers of the Empire are irresistibly drained.'

Dr John Watson – *A Study in Scarlet*

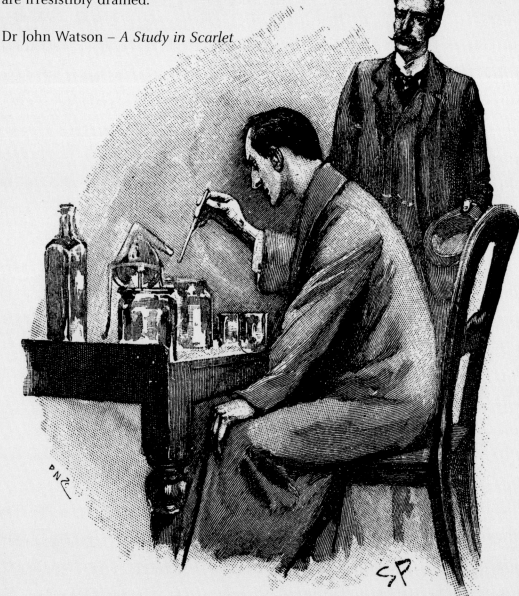

" HOLMES WAS WORKING HARD OVER A CHEMICAL INVESTIGATION."

The Albert Hall

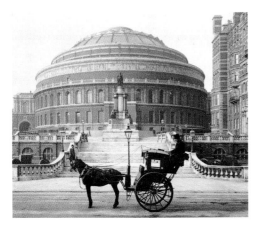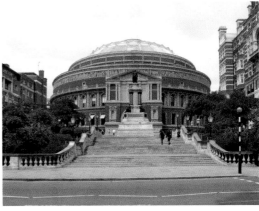

Above: Little changed, the view from Consort Road. (*LoC, Jongleur100*)

Affectionately dubbed the 'Nation's Village Hall', this upturned jelly-mould of a building was opened by Queen Victoria as the Royal Albert Hall in 1871, and along with the nearby memorial it commemorates the life of Prince Albert. Designed by two officers of the Royal Engineers, it is actually elliptical in plan, and the notorious echo was eventually solved with acoustic diffusion mushrooms installed in 1969.

The Royal Albert Hall, South Kensington:
· Holmes proposes that they go to hear Carina sing here. *The Adventure of the Retired Colourman.*
 See also – Theatres and Concert Halls, p44.

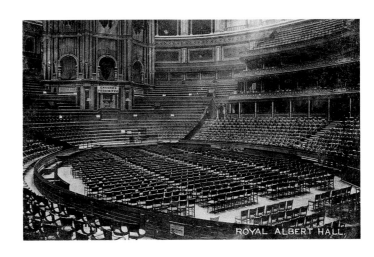

Hammersmith, Chiswick & Fulham

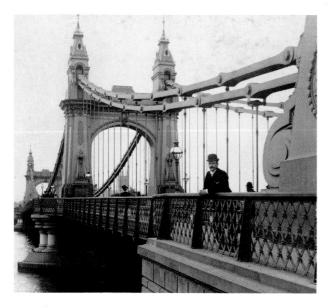

Above: Hammersmith's 1887 iron suspension bridge over the Thames, then and now. (*LoC/Andrew Malzoff, Dreamstime*)

Hammersmith and Chiswick were once independent settlements located in west London between the A4 road and the northern bank of the upward bend of the Thames. One of Hammersmith's most notable landmarks is the suspension bridge just to the south. The original bridge, designed by William Tierney Clark and built in the 1820s, featured two stone-built suspension towers supporting eight chains made up of wrought iron bars. By the 1870s this structure was already proving inadequate for the increase in heavy road traffic and a replacement was designed by Sir Joseph Bazelgette. The stone piers were retained to support a new wrought iron superstructure. Opened by the Prince of Wales in 1887, this is the bridge that Holmes would have known. Beefed-up and refurbished, it still carries the traffic over this part of the Thames.

The bridge, and Chiswick, both make an appearance in *The Adventure of the Six Napoleons* when Holmes and Watson return from their enquiries south of the river.

'We drove to a spot on the other side of the Hammersmith Bridge. Here the cabman was directed to wait. A short walk brought us to a secluded road fringed with pleasant houses, each standing in its own grounds. In the light of a street lamp we read "Laburnum Villa" upon the gate-post of one of them.'

Hammersmith:
- At the time of Eduardo Lucas's murder, his valet was out visiting a friend in Hammersmith. *The Adventure of the Second Stain.*
- Vipors Vigor, the 'Hammersmith Wonder', is mentioned in Holmes's record book. *The Adventure of the Sussex Vampire.*
- Holmes and Watson take a four-wheeler to the other side of Hammersmith Bridge. *The Adventure of the Six Napoleons.*

Chiswick:
- Laburnum Lodge, in Laburnum Vale, described as 'a secluded road fringed with pleasant houses', is the home of Josiah Brown, owner of one of the Napoleon plaster busts. *The Adventure of the Six Napoleons.*

Fulham Road:
- Premises of dog dealers Ross & Mangles. *The Hound of the Baskervilles.*

Hurlingham:
- Baron Gruner played polo at the Hurlingham Club. *The Adventure of the Illustrious Client.*

Hampstead

In his guidebook George Bradshaw describes Hampstead Heath as, 'Situated in the midst of fine open country, which from its elevated character, presents many beautiful views of the city and country to the south ... The air is remarkably salubrious.' Driven by the spread of the railways in the nineteenth century, urban sprawl has surrounded and subsumed the village of Hampstead, which has become famous for its expensive houses and the high concentration of millionaires in the area. Hampstead Heath, known simply as 'the Heath' by locals, has survived intact and is the largest of London's ancient parks, covering some 790 acres. An important refuge for wildlife, it is also one of the highest points in the city and from Parliament Hill visitors can still enjoy unimpeded views of the capital's skyline, including St Paul's.

Hampstead:
- 17 Potters Terrace, Hampstead, Mr Hall Pycroft's 'diggings'. *The Adventure of the Stockbroker's Clerk.*
- Appledore Towers in Hampstead is the home of the blackmailer, Milverton, described by Holmes as 'the worst man in London'. Holmes and Watson break into the house and while there witness his murder. *The Adventure of Charles Augustus Milverton.*
- Hales Lodge, home of Cecil James Barker. *The Valley of Fear.*
- Mr Warren finds himself deposited on Hampstead Heath after being abducted. *The Adventure of the Red Circle.*

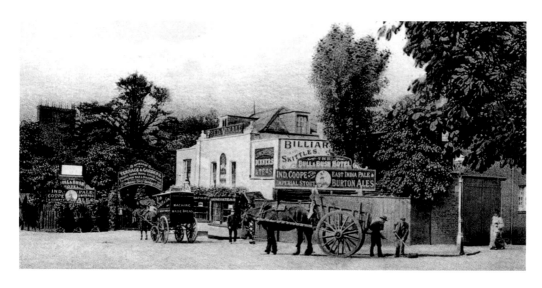

The famous Bull & Bush Hotel on Hampstead Heath, *c.* 1905.

Harrow & North West London

A clutch of Harrow's straw-hatted schoolboys, *c.* 1920.

It was rare for Conan Doyle to allow Holmes and Watson to stray into the less familiar northern side of London. Apart from Count Negretto's house in *The Adventure of the Mazarin Stone* and a central role in the eponymous *Three Gables*, the area is relegated to providing plausible residential addresses for an assortment of maiden aunts or the friends of central characters.

Harrow on the Hill is particularly associated with the straw-hatted boys of the Harrow public school (now an independent school), although this aspect of the town was never incorporated into any of the Sherlock Holmes stories. In his nineteenth-century railway guides, George Bradshaw was much taken by the view from Harrow's hill when 'the landscape is lit up with the gorgeous and glowing sunset of a summer's eve ... It commands a delightful view of the wide, rich valley through which the Thames stretches its sinuous course'.

Harrow and North West London:
- Horonia Westphail, aunt of Helen Stoner, lives near Harrow. *The Adventure of the Speckled Band.*
- Three Gables is located in Harrow Weald. Holmes is informed by Mary Maberley that it is a short walk from Weald Station. *The Adventure of the Three Gables.*
- Effie goes to live with her maiden aunt in Pinner, Middlesex. *The Adventure of the Yellow Face.*
- 136 Moorside Gardens, NW London, home of Count Negretto Sylvius. *The Adventure of the Mazarin Stone.*
- John Ryder's friend, Maudsley, lives in Kilburn. *The Adventure of the Blue Carbuncle.*

Hyde Park

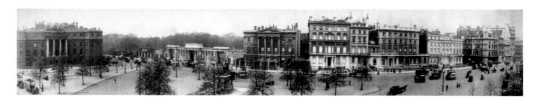

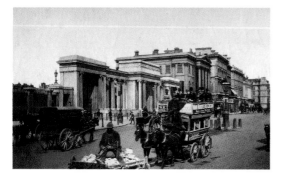
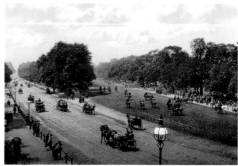

Above: Panoramic view of Hyde Park Corner with Park Lane centre and Piccadilly to the right. Plus the entrance to Hyde Park and Rotten Row.

Combined with Kensington Gardens on its western side, Hyde Park covers 630 acres. It was Henry VIII who acquired the manor of Hyde and had it enclosed to create a deer park and hunting ground. The park is divided by the Serpentine, created in the eighteenth century by damming the Westbourne. In 1851 Hyde Park was the site for the Great Exhibition, held in Joseph Paxton's magnificent 'Crystal Palace', later re-erected in a modified form at Sydenham – see p79. Running east to west across the southern side of the park is Rotten Row. The name is thought to come from 'rotteran' meaning 'to muster'. It was created as a private road for William III and by Holmes's time had become a popular venue for wealthy socialites to ride their horses.

Hyde Park:
- The home of Aloysius Doran is in Lancaster Gate, Bayswater, to the north of Hyde Park. It is the location of the wedding breakfast from which Hatty flees. Exact location unknown, although the park is visible from the window. Hatty Doran is seen with Flora Miller in Hyde Park. Hatty's wedding clothing is found by a park-keeper floating in the Serpentine, which Lestrade dredges for her body. *The Adventure of the Noble Bachelor.*

See also – Park Lane on p31, and Kensington, opposite.

Kensington

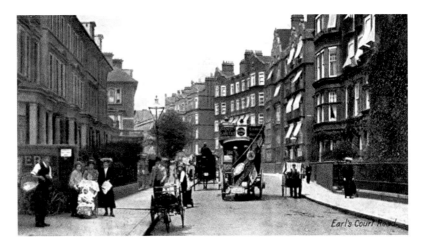

Above: The Earl's Court Road in Kensington, *c.* 1900.

Dr Watson had a practice in Kensington, as he recalls in *The Adventure of the Norwood Builder.*

'At the time of which I speak Holmes had been back for some months, and I, at his request, had sold my practice and returned to share the old quarters in Baker Street. A young doctor, named Verner, had purchased my small Kensington practice, and given with astonishingly little demur the highest price that I ventured to ask – an incident which only explained itself some years later when I discovered that Verner was a distant relation of Holmes, and that it was my friend who had really found the money.'

Kensington is more than just another affluent district of west London, i.e. posh area, posh houses and posh shops. It is also home to a cluster of national museums, including the V&A, the Natural History Museum and the Science Museum. It is bordered to the north-east by Kensington Gardens and Hyde Park, with the Royal Albert Hall located on Kensington Gore facing the Albert Memorial and the parks.

Kensington:
- Latimer tells Mr Melas that his home is in Kensington, but it is actually elsewhere. *The Adventure of the Greek Interpreter.*
- The sellers of several Napoleon busts, Harding Brothers, are located on Kensington High Street, two doors from the station. Campden House Road is the location of one of the smashed busts.

- 131 Pitt Street, Kensington, is the scene of a murder. *The Adventure of the Six Napoleons.*
- Watson refers to retracing his steps to Kensington. *The Adventure of the Empty House.* He also mentions selling his 'small Kensington practice' in *The Adventure of the Norwood Builder.*
- 13 Lower Burke Street, home of Mr Culverton Smith, mentioned as being in the vague borderland between Notting Hill and Kensington. *The Adventure of the Dying Detective.*
- Albermarle Mansion, Kensington, home of Melville, a mutual friend of Eccles and Garcia. *The Adventure of Wisteria Lodge.*
- Holmes dines at Goldini's Restaurant in Gloucester Road, Kensington, before investigating the murder scene at 13 Cauldfield Gardens. This is the address for Hugo Oberstein. It is described as 'one of those lines of flat-faced, pillared, and porticoed houses which are so prominent a product of the middle-Victorian epoch in the West End'. *The Adventure of the Bruce-Partington Plans.*

Olympia:
- Baron Von Herling, an alias for Sherlock Holmes, refers to Von Bork winning a prize in the four-in-hand here. *His Final Bow.*

See also – Albert Hall p55, and Hyde Park on p60.

A high-society picnic in Kensington Gardens. (*LoC*) The famous statue of Peter Pan was placed in the Gardens in 1912.

Notting Hill & St John's Wood

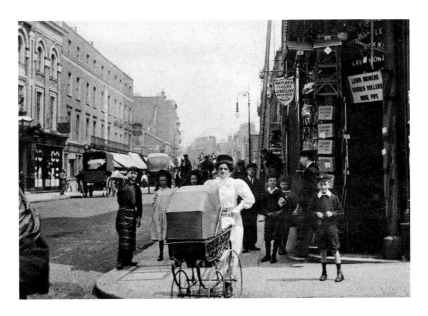

Above: Notting Hill nanny with pram, *c.* 1900. (*CMcC*)

Notting Hill was rocketed into public awareness by the 1999 film of the same name. Located to the north side of Kensington, it is now regarded as a very fashionable area with its terraces of large Victorian town houses. This was largely the case in Sherlock Holmes's day, when it was considered by the upper middle-class as an affordable extension and alternative to Kensington and Belgravia. But it also had associations with 'alternative', dare I say 'artistic', lifestyles.

In contrast, St John's Wood, to the north-west of Regent's Park and not a million miles away from Baker Street, was developed in the nineteenth century as an area of low-density living with highly desirable 'villa'-style houses. No wonder Conan Doyle placed 'the woman', Irene Adler, in a 'bijou villa' in St John's Wood. Today it is said to have the fifth most expensive postcode in London, with an average house costing around the two million pound mark.

Notting Hill:
- The escaped convict Seldon is described as a Notting Hill criminal. *The Hound of the Baskervilles.*
St John's Wood:
- Briony Lodge in Serpentine Avenue, a 'bijou villa' and home of 'the woman', Irene Adler, exact location unknown. *A Scandal in Bohemia.*

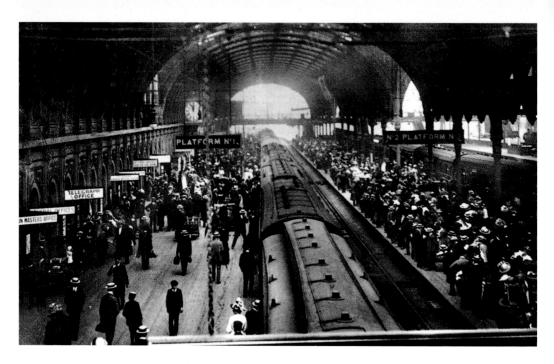

Above: The Grand Departure Platform at Brunel's Paddington Station.
Below: The Paddington Hotel on Praed Street, with station roof behind.

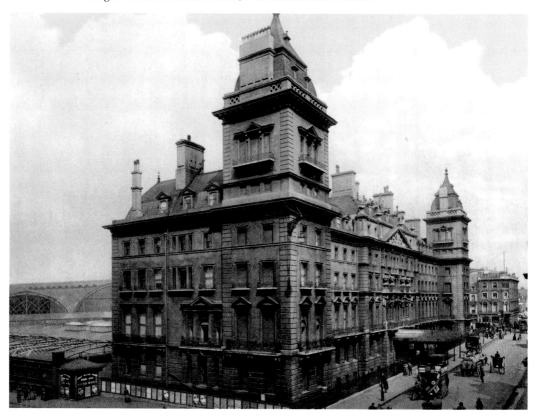

Paddington

Paddington Station is a wonderful place with its great arches of iron and glass designed by the celebrated Victorian engineer Isambard Kingdom Brunel. It is all the more remarkable because it is not the original station. When the Great Western Railway was nearing completion, the company had neither the money nor the land to build the big prestigious London terminus it had hoped for and a temporary wooden station was erected to the north of the Bishop's Road Bridge. This gave Brunel that rare thing in engineering history, a breathing space and a second shot at a major project. By the time he got the go-ahead for a new station, his ideas has been shaped by a revolution in the use of wrought iron and glass which had been pioneered by Joseph Paxton with his giant conservatories at Chatsworth and the Great Exhibition. The result was a station that is unlike any of Brunel's earlier railway buildings, which tended to pastiche either Elizabethan or Italianate styles. The New Paddington Station opened in 1854 and a fourth arched transept was added in Edwardian times.

Paddington Station:
- Holmes and Watson rendezvous at Paddington Station and they board the 11.15 train to Boscombe Valley near Ross, Herefordshire. *The Boscombe Valley Mystery.*
- Holmes and Watson take the train to King's Pyland in Dartmoor. *The Adventure of Silver Blaze.*
- Watson catches a train at Paddington on the way to Dartmoor. *The Hound of the Baskervilles.*

Paddington area:
- Watson's practice is 'no great distance from Paddington' and the injured Victor Hatherley is brought to him for attention after arriving from Eyford, Berkshire. Later on, Holmes and Watson catch the train for Eyford from here. *The Adventure of the Engineer's Thumb* and *The Adventure of the Stockbroker's Clerk.*
- Holmes, posing as a bookseller, tells Watson he is a neighbour whose shop is on the corner of Church Street, Kensington. *The Adventure of the Empty House.*

"I AM DELIGHTED THAT YOU HAVE COME DOWN, MR. HOLMES."

Richmond & Kingston-upon-Thames

Two more highly sought-after residential locations. Richmond and Kingston, just to its south, are near neighbours located beside the meandering Thames in south-west London. Neither is quite in the countryside any more, but they are not far off. Richmond seems to have vaguely sporting associations in the Sherlock Holmes stories, with references to rugby – played by Dr Watson incidentally – and it is one of numerous locations where the mysterious cyclist in *The Valley of Fear* is reported as being seen. Cycling had flourished as a popular pastime by the late nineteenth century, for men and women alike, thanks to a number of refinements, including the introduction of Dunlop's pneumatic tyre in 1888 and the development of free-wheel and coaster brake mechanisms in the 1890s.

Richmond:
- One of several possible sightings of the elusive cyclist. *The Valley of Fear.*
- Robert Ferguson played rugby for Richmond, and once threw Watson into the crowd at the Old Deer Park. *The Adventure of the Sussex Vampire.*

Kingston-upon-Thames:
- Vernon Lodge, the home of Baron Gruner, is near Kingston. *The Adventure of the Illustrious Client.*

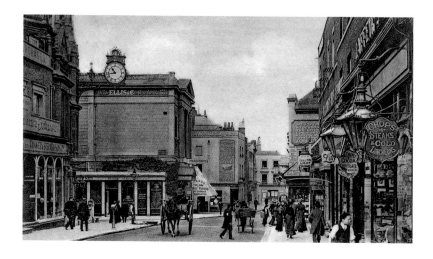

Hill Street and Town Hall, Richmond.

Esher & Oxshott Common

Above: Postcard image of the village green in Esher, *c.* 1900.

'I drove to the place – about two miles on the south side of Esher. The house was a fair-sized one, standing back from the road, with a curving drive which was banked with evergreen shrubs. It was an old, tumble-down building in a crazy state of repair.'
John Scott Eccles describing Garcia's house in *The Adventure of Wisteria Lodge*.

The town of Esher and the nearby village of Oxshott are slightly further to the south from Richmond and Kingston-on-Thames, right on the south-western edge of London's built-up area. Esher has a common comprised of several wooded areas, while neighbouring Oxshott has a more open common usually referred to as Oxshott Heath. The coming of the railway in the 1880s brought an influx of wealthy residents and, despite the despicable murder of Garcia, Esher and Oxshott are among the most expensive and sought-after suburbs of London.

Esher:
· Nearest centre to Wisteria Lodge, which is said to be between Esher and Oxshott. Holmes and Watson also visit The Bull in Esher. *The Adventure of Wisteria Lodge*.

Oxshott Common:
· Garcia, of Wisteria Lodge, is found dead on Oxshott Common in a lonely corner nearly a mile from his home, his head bashed to pulp. Also, Oxshott Towers is given as the residence of Sir George Ffolliott. *The Adventure of Wisteria Lodge*.

South London

'Holmes was sunk in profound thought, and hardly opened his mouth until we had passed Clapham Junction. "It's a very cheering thing to come into London by any of these lines which run high and allow you to look down upon the houses like this." I thought he was joking, for the view was sordid enough ...'

The Adventure of the Naval Treaty

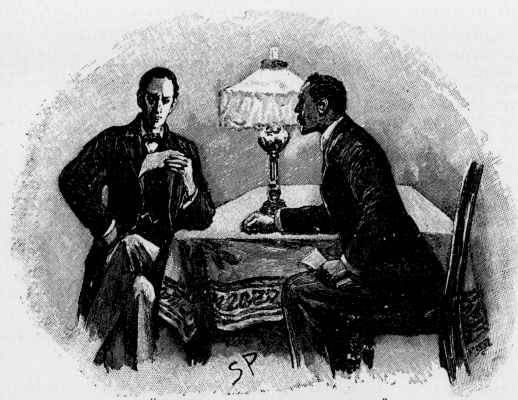

" THE KEY OF THE RIDDLE WAS IN MY HANDS."

Blackheath, Lewisham & Lee

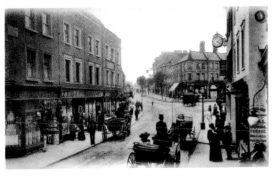

Above: Blackheath village and the local rugby team in action.

The widely held belief that Blackheath Common derived its name as a mass burial pit for victims of the plague is unsubstantiated and it actually stems from the dark coloured heathland in the area. Blackheath itself is now a prosperous 'village suburb' of London.

Blackheath:
- Holmes goes to Torrington Lodge, the home of John Hector McFarlane. *The Adventure of the Norwood Builder.*
- Godfrey Staunton played rugby for Blackheath. *The Adventure of the Missing Three-Quarter.* Watson also played rugby, according to McFarlane. *The Adventure of the Sussex Vampire.*
- When catching the train to London from here, Watson sees a tall, dark man dart into the adjacent carriage. *The Adventure of the Retired Colourman.*

Lewisham:
- The Randalls, wrongly accused of the murder, are referred to as the 'Lewisham gang of burglars'. *The Adventure of the Abbey Grange.*
- Home of Joshua Amberley, who murders his wife and her lover, and nearby of Dr Ray Ernest. *The Adventure of the Retired Colourman.*

Lee:
- The Cedars is the home of the St Clair family. *The Man With the Twisted Lip.*
- Popham House, the home of John Scott Eccles. *The Adventure of Wisteria Lodge.*

Brixton

Above: Holmes attempts to stop the old lady's burial in *The Disappearance of Lady France Carfax.*
Right: The Goose Club geese came from Brixton. (*LoC*)

The Brixton road, which runs from north to south from Kennington through South Lambeth and Stockwell, dates back to Roman times. The area was rural until the early nineteenth century, and it was the completion of the Vauxhall Bridge in 1816, followed by the coming of the railways in the 1860s, that brought easier access to central London, resulting in rapid urban development. Conan Doyle repeatedly uses Brixton as the address for many of his working class characters. In *A Study in Scarlet* Dr Watson gives a bleak account of his first impression of travelling down the Brixton Road. 'It was a foggy, cloudy morning, and a dung-coloured veil hung over the house-tops, looking like the reflection of the mud-coloured streets beneath.'

Following a post-war influx of immigrants – the so-called 'Windrush generation' – Brixton has become well known as a multi-ethnic community. Eddie Grant's song *Electric Avenue* refers to the Brixton market street, built in the 1880s and one of the first in the UK to have electric lighting installed.

Brixton:

- As a lure to trap the killer, Holmes places an advertisement in the newspapers falsely stating that a gold wedding ring had been found in the Brixton Road, between the White Hart Tavern and Holland Grove. Also, 3 Lauriston Gardens, off the Brixton Road, is the fictitious address where the body of Enoch J. Drebber is found. Holmes and Watson travel there by Hansom Cab. *A Study in Scarlet.*
- J. Davenport lives in Lower Brixton. *The Adventure of the Greek Interpreter.*
- 16 Ivy Lane, Brixton, is the home of Tangey, the commissionaire at the Foreign Office. *The Adventure of the Naval Treaty.*
- According to the *Daily Gazette* a lady fainted on the Brixton bus. *The Adventure of the Red Circle.*
- 36 Poultney Square, Brixton, is the fictitious address of Fraser and Holy Peters. Holmes and Watson travel down Brixton Road. *The Disappearance of Lady Frances Carfax.*
- Mrs Merrilow and Mrs Ronder, her veiled lodger, live in South Brixton. *The Adventure of the Veiled Lodger.*
- Killer Evans is last heard of at a nursing home in Brixton. *The Adventure of the Three Garridebs.*
- Inspector Stanley Hopkins lives at 46 Lord Street. *The Adventure of the Black Peter.*
- 117 Brixton Road is the address of Mrs Oakshott, who fattens the geese, including the one in which the carbuncle is hidden. *The Adventure of the Blue Carbuncle.*
- A branch surgery and dispensary of Dr Barnicot is in Lower Brixton. *The Adventure of the Six Napoleons.*

Bromley & Chatham

Above: Postcard view of Chatham on the banks of the Medway.
Right: A steam press in action in one of the ship building yards.

'After a long and weary journey we alighted at a small station some miles from Chatham. While a horse was being put into a trap at the local inn we snatched a hurried breakfast, and so we were all ready for business when we at last arrived at Yoxley Old Place.'
The Adventure of the Golden Pince-Nez.

Beckenham, Chiselhurst and Bromley itself are all suburban districts within the London Borough of Bromley, about ten miles to the southeast of central London. Chatham in Kent is the furthermost east of the locations in this survey and is on the banks of the Medway in Kent. No wonder then that Dr Watson found the journey long and wearisome. Chatham is closely associated with the naval dockyards and many hundreds of vessels were built here.

Beckenham and Bromley area:
- Sophy Kratides lives at The Myrtles, Beckenham, about half a mile from Beckenham Station. Holmes and Watson take the train to Beckenham Junction to track her down. *The Adventure of the Greek Interpreter.*
Chatham:
- Holmes and Watson travel between Charing Cross and Chatham to conduct their investigations at Yoxley Old Place. *The Adventure of the Golden Pince-Nez.*
Chiselhurst:
- Holmes and Watson alight at Chiselhurst Station on the way to Abbey Grange, two miles away. *The Adventure of the Abbey Grange.*

Greenwich & Woolwich

Above: Greenwich Town Hall and Rotunda at Woolwich Arsenal. (*CMcC*)

South of the Thames and heading eastwards, we come to Greenwich and then Woolwich. Greenwich is famous for its splendid Royal Hospital/ Naval College and the Royal Observatory built by Sir Christopher Wren, for the Greenwich Meridian and Mean Time, plus the Queen's House and National Maritime Museum located within Greenwich Park, plus the newly restored *Cutty Sark*. And the Dome.

Woolwich is also within the Royal Borough of Greenwich. It was part of Kent until the County of London was created in 1889. Historically it was home to the Woolwich Dockyard and the Woolwich Arsenal, which dates back to 1471. Holmes and Watson visit the Arsenal in *The Adventure of the Bruce-Partington Plans*.

Greenwich:
- Premises of Venner & Matheson, engineers, where Victor Hatherley had previously been apprenticed. *The Adventure of the Engineer's Thumb.*
Woolwich Arsenal:
- Arthur Cadogen West is a clerk at the Arsenal, Holmes and Watson visit during their investigations, arriving by train at Woolwich Station. They go to the home of Sir James Walter, described as 'a fine villa with green lawns stretching down to the Thames', as well as that of the Cadogen Wests on the edge of the town. Before leaving, they question the clerk in the station ticket office. *The Adventure of the Bruce-Partington Plans.*

73

Lambeth & Kennington

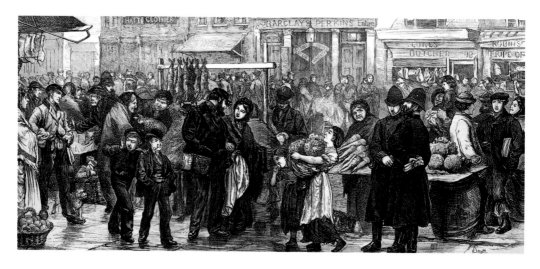

Above: New Cut, Lambeth, 1872.
Opposite page: Old riverside houses being cleared for the construction of the South Embankment. (*LoC*)

Lambeth:
- 3 Pinchin Lane, Lambeth, is described as 'a row of shabby, two-storey brick houses in the lower quarter of Lambeth'. The fictitious address for Mr Sherman, the 'animal stuffer'. *The Sign of Four.*
- Holmes says, 'I shall walk down to Doctors' Commons, where I hope to get some data which may help us in this matter.' The Doctors' Commons was a society of lawyers practising civil law. Its building in Knightrider Street, Lambeth, was noted for its large library. Although it was demolished in 1867, this Holmes story is set in 1883. *The Adventure of the Speckled Band.*

Kennington:
- Morse Hudson has a picture and sculpture shop in Kennington Road, Lambeth, where the first Napoleon bust is smashed. Dr Barnicot also lives within a few hundred yards of it. *The Adventure of the Six Napoleons.*
- Fraser is tracked along Kennington Road, and Stimson & Co. undertakers are located here. *The Disappearance of Lady Frances Carfax.*
- Toby the sniffer dog leads them through Streatham, Brixton and Camberwell to the foot of Kennington Lane. *The Sign of Four.*
- 46 Audley Court, Kennington Park Gate, fictitious address of John Rance, the police constable who discovered the body of Enoch J. Drebber. *A Study in Scarlet.*

Nine Elms:

- Toby the dog takes Holmes and Watson on a false trail down Nine Elms to Broderick & Nelson's timber-yard, 'just past the White Eagle tavern'. Also, unknown location for the home of Thaddeus Sholto. *The Sign of Four.*

Peckham:

- 3 Mayfield Place is the false address of Sally Dennis, said to be her niece by the old woman claiming the wedding ring. *A Study in Scarlet.*

Camberwell:

- Torquay Terrace, fictitious address of Madame Carpentier's boarding house, where Drebber and Stangerson had stayed. John Underwood & Sons, hat-makers, have premises at 129 Camberwell Road. *A Study in Scarlet.*
- Mary Morston lives with Mrs Cecil Forrester in Lower Camberwell, and Watson visits her there. *The Sign of Four.*
- 31 Lyon Place, fictitious address of Mary Sutherland. *A Case of Identity.*
- Reference to Camberwell poisoning case. *The Five Orange Pips.*
- Porlock sends letter from Camberwell Post Office. *The Valley of Fear.*
- Miss Dobney, old governess of Lady Fairfax, retires in Camberwell. *The Disappearance of Lady Frances Carfax.*

Clapham Junction:

- Holmes and Watson pass through Clapham Junction on their return from Dartmoor. *The Adventure of Silver Blaze.*
- After finding himself on Wandsworth Common, Mr Melas is instructed to walk the 'mile or so' to Clapham Junction for the last train to Victoria. *The Adventure of the Greek Interpreter.*
- Holmes and Watson return from Woking by train to Waterloo. On passing Clapham Junction, Holmes remarks how he enjoys looking down on the houses. *The Adventure of the Naval Treaty.*

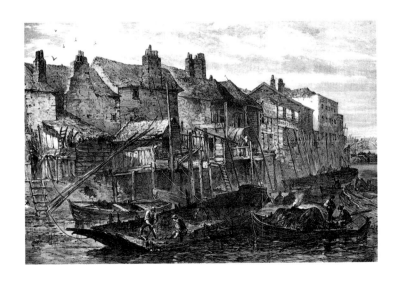

London Bridge

It is said that when the Americans decided to buy London Bridge, they thought they were getting Tower Bridge. It's a common mistake. Linking the City with Southwick and the Borough on the south side of the river, it is thought that a bridge has been on this site since Roman times. There have been several manifestations and at one time the bridge was lined with shops and houses. The London Bridge that Holmes and Watson would have known was built in 1831 and remained in situ until it was dismantled in 1967, sold to the Americans and sent to Lake Havasu City in the USA.

The bridge itself doesn't get a mention in the Sherlock Holmes stories, but London Bridge Station on the south side does, primarily in connection with the train routes to the south-east. London Bridge Station is the oldest of the capital's railway termini and originally opened in 1836 to jointly serve the London & Greenwich Railway and the London & Croydon Railway. In 1849 the station was rebuilt in an enlarged form by the London Brighton & South Coast Railway.

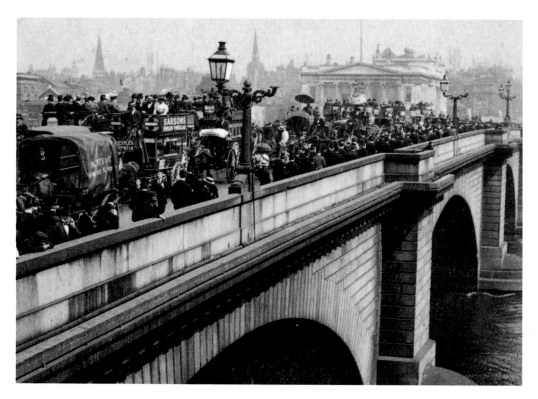

A busy London Bridge crammed with traffic. (*LoC*)

LONDON BRIDGE STATION.

London Bridge Station:

- Holmes and Watson take a train from London Bridge to Beckenham. *The Adventure of the Greek Interpreter.*
- After travelling from Norwood, John Hector McFarlane is followed to Baker Street from the station. *The Adventure of the Norwood Builder.*
- According to Mycroft, this is the station Arthur Cadogan West would have used on his route to Woolwich. *The Adventure of the Bruce-Partington Plans.*
- Watson returns here from Blackheath and sees the mysterious 'tall dark figure' once again. *The Adventure of the Retired Colourman.*

Borough:

- 3 Tupey Street, the fictitious address of cab driver John Clayton. *The Hound of the Baskervilles.*

London Stations:

Charing Cross p12, Cannon St p17, Euston p20, King's Cross and St Pancras p26, Marylebone p28, Victoria p48, Paddington p64, Waterloo p82.

South of London

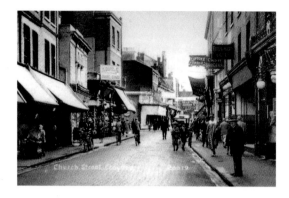

Church Street in the centre of Croydon.

Right out on the southernmost outskirts of our listing – which for the sake of argument extends 10 miles or so from Charing Cross to encompass the Greater London area – we have the towns of Croydon, Wallington and Penge. All three are featured in *The Adventure of the Cardboard Box*, although none makes any particular contribution to the plot apart from being respectable residential addresses for Susan and Sarah Cushing.

Watson describes the scene after arriving at Croydon Station along with Holmes and Inspector Lestrade. 'A walk of five minutes took us to Cross Street, where Miss Cushing resided. It was a very long street of two-storey brick houses, neat and prim, with whitened stone steps and little groups of aproned women gossiping at the doors.'

Croydon:
- Cross Street is the home of Miss Susan Cushing, who receives the parcel containing two human ears. *The Adventure of the Cardboard Box.*
Wallington:
- Sarah, the sister of Susan Cushing, lives in the fictitious New Street. *The Adventure of the Cardboard Box.*
Penge:
- Former home of Miss Susan Cushing, where she had 'led a most respectable and quite life' for twenty years. However, she did let apartments out to three medical students and they were suspected of sending the gory parcel. *The Adventure of the Cardboard Box.*

Sydenham & Norwood

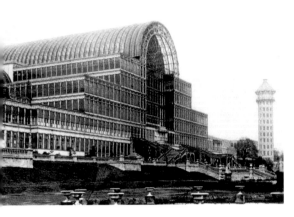

Above: The Crystal Palace at Sydenham, in its prime and in ruins following the fire in 1936. Brunel's water towers were demolished during the Second World War. (*CMcC*)

There are many instances where Arthur Conan Doyle included parts of London he was personally familiar with, so it was natural that the Sydenham and Norwood areas should get a number of mentions as he lived in the area at one time. As with some of the other south London districts, they tend to be the homes of the middle or working class characters such as Jack and Effie Grant Munro in *The Adventure of the Yellow Face* – perhaps one of the less well known of the Holmes stories.

> 'I went as far as the Crystal Palace, spent an hour in the grounds, and was back in Norbury by one o'clock. It happened that my way took me past the cottage, and I stopped for an instant to look at the windows to see if I could catch a glimpse of the strange face which had looked out at me on the day before.'

The Crystal Palace was the dominant feature in the area. This was the same structure of iron and glass that had stood on Hyde Park for the Great Exhibition of 1851. When the exhibition had finished it was dismantled, taken to the Sydenham site and reopened in a modified and enlarged form. The grounds were laid out as a pleasure park with extensive gardens and fountains, the latter supplied by a pair of water towers designed by Isambard Kingdom Brunel and erected slightly apart and at either end of the main building. Exhibitions, concerts and sporting events were held there during Sherlock Holmes's time and the Sydenham area became quite fashionable. Then, one night in 1936 the Crystal Palace was destroyed in a ferocious fire that was visible to people all over London.

Only the two towers remained and, although these were used as public viewing platforms for some time, they were demolished in the early stages of the Second World War. It was feared they would serve as prominent navigational aids to the Luftwaffe bombers heading towards London.

The Crystal Palace, Sydenham and Norwood:

- Jack and Effie Grant Munro live in a 'nice eighty-pound-a-year villa' in Norbury. Jack takes a walk to the Crystal Palace and spends an hour in the grounds. *The Adventure of the Yellow Face.*
- The Randall Gang did a 'job' here a fortnight before the Abbey Grange murder. The ship's captain Jack Crocker lives in Sydenham. *The Adventure of the Abbey Grange.*
- Deep Dene House, Lower Norwood, at the Sydenham end of Sydenham Road, was the home of murder victim Jonas Oldacre. John Hector McFarlane spends the night of the murder at the Anerley Arms. *The Adventure of the Norwood Builder.*
- Major Sholto retired to Upper Norwood, and Bartholmew Sholto's body is discovered at Pondicherry Lodge, although the precise location is not stated. Toby the sniffer dog leads Holmes and Watson through Streatham on the way to Kennington Lane. *The Sign of Four.*
- Alexander Holder lives in Streatham, from where the Beryl Coronet is stolen. *The Adventure of the Beryl Coronet.*
 See also – Conan Doyle's London, p91.

Postcard of Brockwell Park in Norwood.

Vauxhall Bridge

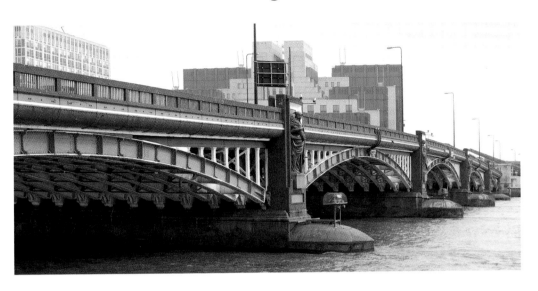

Above: Vauxhall Bridge looking south. (*Clickos/Dreamstime*)

The present Vauxhall Bridge, linking Pimlico and Millbank on the north of the Thames with Vauxhall on the south side, is a replacement for an earlier iron bridge. This had been opened in 1816 only after several changes of design and engineer, and its original name of Regent Bridge was changed to the Vauxhall Bridge shortly afterwards. Following a shaky start as a toll bridge, it eventually became profitable thanks to rapid urban growth in the mid-nineteenth century, especially south of the river. By 1879 the iron bridge had been purchased by the Metropolitan Board of Works, but inspection revealed that the two central piers were badly eroded and in 1889 Parliamentary consent was granted for the construction of a replacement. Plans for a concrete bridge faced with granite were abandoned – it would have been too heavy – and the steel structure eventually opened in 1906. Thus Sherlock Holmes would have been familiar with both bridges. The bronze figures above the piers represent Agriculture, Architecture, Pottery, Science, Fine Arts, Local Government and Education.

Vauxhall Bridge:
- Holmes, Watson and Miss Morston are taken on a circuitous route, eventually passing over the bridge to the Surrey side to the home of Thaddeus Sholto. Later on, after the capture of Jonathan Small, Watson is dropped off by the bridge along with the empty treasure box. *The Sign of Four.*

Waterloo Station

The present Waterloo Station is completely different to the one that Sherlock Holmes would have known. The original station, built for the London & South West Railway, opened in July 1848 as Waterloo Bridge Station. It was raised on arches above the marshy ground and as it expanded the station became notoriously ramshackle and confusing for railway travellers and the butt of much mockery in the pages of *Punch*. By the turn of the century the number of platforms had grown to sixteen, but only ten were numbered and the remainder had nicknames such as 'Cyprus Station' and 'Khartoum Station'. In 1899 the directors of the LSWR bit the bullet and instigated a major rebuild, with the new Waterloo opening in stages, starting with ten platforms in 1910. By the time the work was eventually completed in 1922, it had twenty-one platforms and a wide, curving concourse stretching for nearly 800 feet. Unfortunately for the LSWR, their glory was short-lived as the 1921 Railways Act would see the end of the company in January 1923 and the birth of the Southern Railway. Today it is Britain's busiest station with 91 million passengers passing through every year.

The original Waterloo Bridge Station for the London & South Western Railway. It was rebuilt in stages and finally completed in 1922.

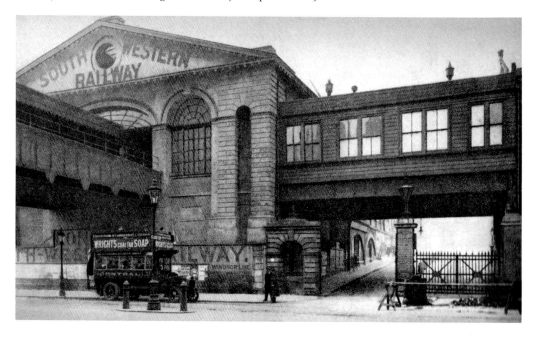

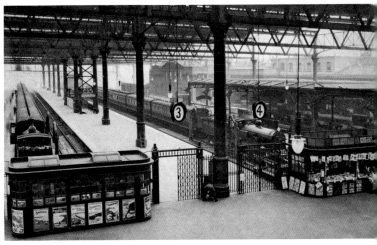

Waterloo Station:

- John Openshaw is on the way to the station when he is attacked by the KKK and thrown into the river near Waterloo Bridge. *The Five Orange Pips.*
- Helen Stoner arrives at Waterloo; later on Holmes and Watson catch a train for Leatherhead. *The Adventure of the Speckled Band.*
- Holmes and Watson take the train to Winchester. *The Adventure of the Copper Beeches.*
- Holmes has supper at Waterloo and later, together with Watson, takes the 11.10 train to Aldershot. *The Adventure of the Crooked Man.*
- Holmes and Watson catch the Portsmouth train to Woking, and later Percy Phelps and Watson return to London via Waterloo, with Holmes joining them the following morning. *The Adventure of the Naval Treaty.*
- Henry Baskerville's train arrives at Waterloo. Shipley's Yard for cabs is said to be near the railway station. *The Hound of the Baskervilles.*
- Violet Smith travels from Waterloo to Farnham, and Watson takes a later train from there. *The Adventure of the Solitary Cyclist.*
- Killer Evans shot a man over cards in a club on Waterloo Road in 1895. *The Adventure of the Three Garridebs.*

See also – Waterloo Bridge on p50.

Above: An illustration of the old station, 1907, and the rebuilt Waterloo.

Wimbledon & Wandsworth

Above: In the nineteenth century the travelling showmen would take their exotic acts, including 'wild beasts', from town to town. (*LoC*)

Two communities next to each other in south London, both with commons. Of the two Wimbledon is perhaps the better known, not least for the Lawn Tennis Championships – the first was held in 1877 – but also for the ecologically astute Wombles. Wimbledon and Wandsworth had been rural settlements until the coming of the railways, Wimbledon with the London & South West Railway in 1838 while the Wandsworth Common Station opened in 1856 on the West End of London & Crystal Palace Railway. Since then both boroughs have seen enormous growth and a rapid increase in population. Attempts to enclose Wimbledon Common in 1864 were thwarted by Parliament and today the combined Wimbledon and Putney Common covers 1,100 acres. The windmill in the centre of the common is where Baden-Powell wrote parts of *Scouting for Boys*, published in 1908.

Wimbledon:
- Ronder's wild beast show was travelling to Wimbledon when the lion attacked. *The Adventure of the Veiled Lodger.*

Wandsworth Common:
- Mr Melas is left here, 'a mile or so from Clapham Junction', after attending to Harold Latimer. *The Adventure of the Greek Interpreter.*

East London

'In rapid succession we passed through the fringe of fashionable London, hotel London, theatrical London, literary London, commercial London, and, finally, maritime London, till we came to a riverside city of a hundred thousand souls, where the tenement houses swelter and reek with the outcasts of Europe.'

The Adventure of the Six Napoleons

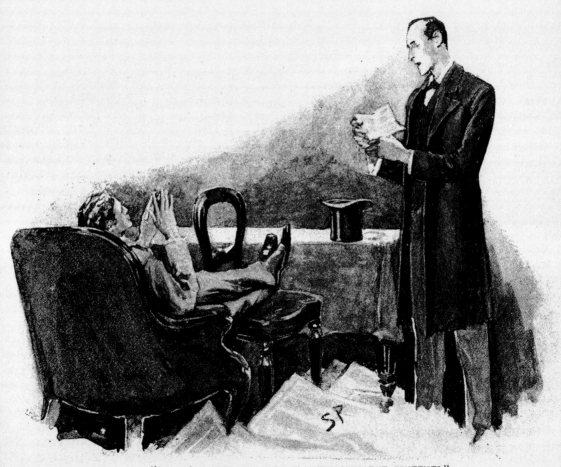

"HE BROKE THE SEAL AND GLANCED OVER THE CONTENTS."

An Opium Den

Above: Gustave Doré's engraving of an opium den in London, and a later photograph of a Victorian 'bachelor den'. (*LoC*)

> 'Through the gloom one could dimly catch a glimpse of bodies lying in strange fantastic poses, bowed shoulders, bent knees, heads thrown back and chins pointing upwards, with here and there a dark, lack lustre eye turned upon the newcomer. Out of the black shadows there glimmered little red circles of light, now bright, now faint, as the burning poison waxed or waned in the bowls of the metal pipes.'

Dr Watson's description of the opium den in Swandum Lane paints a pitiful picture, but the Victorian attitude towards drugs was ambivalent. After all, the British Empire had been complicit in the international opium trade and the possession or use of drugs such as cocaine and even heroin remained legal in the nineteenth century. Tincture of Laudanum, for example, was available from the chemists as a pain killer. Certainly Watson was aware of Holmes's use of cocaine, injected in a 7 per cent solution, and the morphine. Watson described it as the detective's 'only vice', but it would be fairer to say that Holmes was a recreational user rather than an addict. It was a part of his life. In *A Scandal in Bohemia* Watson describes how Holmes would be 'alternating from week to week between cocaine and ambition, the drowsiness of the drug and his own keen nature.'

The Bar of Gold, Swandam Lane:
- An opium den, described as being in 'a vile alley to the east of London Bridge', frequented by Isa Whitney. *The Man With the Twisted Lip.*

Prisons

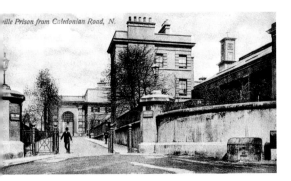

Above: Best seen from the outside, Pentonville Prison, and the interior of Newgate Courts. (*CMcC*)

A report from 1862 reveals that London had a prison population of over 120,000. The sentences handed out by the courts were severe and convicted prisoners faced a regime of hard manual labour and regular punishment, including floggings. Conan Doyle personally championed the cause of several men who had been wrongly convicted.

Pentonville:
· James Ryder's friend Mortimer served time in the prison. *The Adventure of the Blue Carbuncle.*

Millbank Penitentiary:
· Holmes and Watson cross the river and disembark near here after losing the trail of Jonathan Small. *The Sign of Four.*

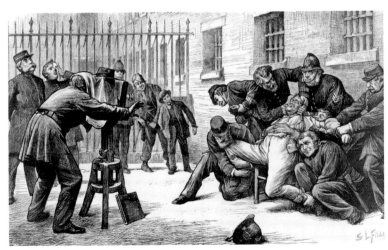

The River Thames & Docks

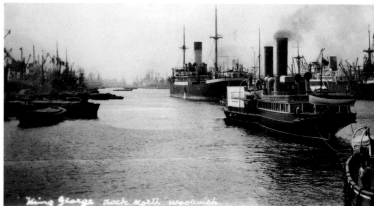

Above: Watermen working on the boats, and the King George Dock at North Woolwich. (*CMcC*)

For centuries the River Thames has been the main artery bringing trade in and out of London. During the nineteenth century a series of enclosed docks was constructed up river from London Bridge, massively increasing the amount of traffic able to use the port. It must have been a wonderfully chaotic and exotic scene, with ships bringing goods from every corner of the British Empire. As a backdrop to crime stories the river and docks offer an endlessly changing pallet of characters and situations. People, and boats, could vanish amid the labyrinth of mooring places and in the world of Sherlock Holmes they frequently did. Various riverside locations are mentioned throughout the stories, and these are covered in the appropriate sections of this survey, but the river and the docks played a central role in two of them, *The Five Orange Pips* and *The Sign of Four*. In the latter Holmes and Watson board a police steam launch in pursuit of Jonathan Small and his mysterious companion in the *Aurora*:

'At Greenwich we were about three hundred paces behind them. At Blackwall we couldn't have been more than two hundred and fifty. I have coursed many creatures in many countries during my chequered career, but never did sport give me such a wild thrill as this mad, flying manhunt down the Thames.'

They catch up with the *Aurora* by the Plumstead Marshes, to the east of Woolwich. Here they discover that the figure slouching in the back of the boat is a 'savage, distorted creature' armed with a short but deadly blow-pipe ...

River and docks:

- The *Lone Star* was moored at the Albert Dock. *The Five Orange Pips.*
- Inspector Lestrade apprehends James Browner on board SS *May Day* at Albert Dock. *The Adventure of the Cardboard Box.*
- Jacobson's boatyard, fictitious, opposite the Tower of London, is where the *Aurora* is hidden under the pretext that the rudder is being repaired. It is here that the chase down the river begins. Also, Mordecai Smith's landing stage is at the end of Broad Street, where the sniffer dog loses the trail of Jonathan Small, on the Lambeth side of river. They take a wherry, a sort of water taxi, back across the river and land near the Millbank Penitentiary. *The Sign of Four.*
- Neville St Clair throws his clothes into the river on the north bank near Swandam Lane just before he is arrested as his own murderer. *The Man With the Twisted Lip.*

Rotherhithe:

- Holmes was working on a case in an alley 'near the river' when he contracted a tropical illness. *The Adventure of the Dying Detective.*

Plumstead Marshes:

- Jonathan Small is apprehended here after the chase down the Thames. *The Sign of Four.*

Left: Unloading one of the ships.
Right: Thames River Police on patrol, *c.* 1960. (*CMcC*)

Stepney & East London

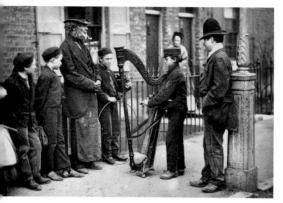

Stepney:
- Gelder & Co., the manufacturers of the Napoleon plaster bust, are located in Church Street. *The Adventure of the Six Napoleons.*
- Home of A. Dorak, who provides the poison. *The Adventure of the Creeping Man.*

Liverpool Street Station:
- Hilton Cubbit travels from Norfolk to Liverpool Street in order to consult Holmes. *The Adventure of the Dancing Men.*
- Watson takes a train to Little Purlington accompanied by Josiah Amberley. *The Adventure of the Retired Colourman.*

East London:
- Count Sylvius is followed by Holmes to Straubenzee's workshop in the Minories. *The Adventure of the Mazarin Stone.*
- James Browner makes a statement to Lestrade at Shadwell Police Station. *The Adventure of the Cardboard Box.*
- 13 Duncan Street, Hounditch, is the address falsely given by Mrs Sawyer, who comes to Baker Street to claim the gold wedding ring found in Brixton. Holmes jumps into the four-wheeler she takes to Duncan Street, but the 'old woman' gets away. *A Study in Scarlet.*
- The location of the Sumner Shipping Agents. *The Adventure of Black Peter.*
- Mycroft refers to the Manor House case. *The Adventure of the Greek Interpreter.*
- One of several possible sightings of the mysterious cyclist. *The Valley of Fear.*

Conan Doyle's London

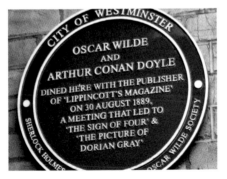

After studying in Vienna, Arthur Conan Doyle came to London in 1891 and set up an opthalmic (eye) clinic at 2 Upper Wimpole Street, in Marylebone. He lived nearby in lodgings at Montague Place. That same year the first six Sherlock Holmes stories were published in *The Strand Magazine*. With the pressure of maintaining two careers making him ill, Conan Doyle abandoned his practice and moved to a house in Tennison Road in South Norwood, Croydon, then part of Surrey. He had married Louise Hawkins in 1885 and the couple had two children before she became ill with tuberculosis. Conan Doyle built a bigger house, called Undershaw, in Hindhead, Surrey, where she could recuperate, but Louise died in 1906. He later remarried, to Jean Lechie, and they had three children. They moved to Windlesham in Crowborough, Sussex, where Sir Arthur Conan Doyle – he was knighted after writing a lengthy pamphlet on the Boer War – died on 7 July 1930. A devout believer in Spirituality, he was buried in Windlesham Rose Garden, but together with Jean was later re-interred in unconsecrated ground in Minstead churchyard in the New Forest.

Conan Doyle (*LoC*) and the blue plaques: 2 Upper Wimpole Street, at Portland Place to commemorate a meeting with Oscar Wilde and his publisher, and on his South Norwood home in Tennison Road. (*Pafcool2*)

Locations indexed by story

There has been much debate concerning the chronological order of the events depicted in the Sherlock Holmes stories. This list of stories is arranged by publication date.

A Study in Scarlet (novel, 1887): 20–21, 25, 35, 42–43, 50, 70–71, 74–75, 90

The Sign of Four (novel, 1890): 15–17, 28–29, 38–39, 44, 51–52, 74–75, 79–80, 81, 87, 88–89

The Adventures of Sherlock Holmes (twelve stories, 1891–92):

A Scandal in Bohemia 12–14, 20–21, 22–23, 38–39, 63

The Red-Headed League 15–17, 18, 22–23, 33–34, 44, 46–47

A Case of Identity 10–11, 15–17, 26–27, 74–75

The Boscombe Valley Mystery 64–65

The Five Orange Pips 50, 82–83, 88–89

The Man With the Twisted Lip 15–17, 36–37, 42–43, 50, 69, 86, 88–89

The Adventure of the Blue Carbuncle 10–11, 19, 28–29, 30–31, 33–34, 59, 70–71, 87

The Adventure of the Speckled Band 59, 74–75, 82–83

The Adventure of the Engineer's Thumb 48–49, 64–65, 73

The Adventure of the Noble Bachelor 10–11, 12–14, 30–31, 45, 60

The Adventure of the Beryl Coronet 15–17, 46–47, 79–80

The Adventure of the Copper Beeches 28–29, 82–83

The Memoirs of Sherlock Holmes (twelve stories, 1892–93):

The Adventure of Silver Blaze 30–31, 48–49, 64–65, 74–75

The Adventure of the Cardboard Box 10–11, 78, 88–89, 90

The Adventure of the Yellow Face 59, 79–80

The Adventure of the Stockbroker's Clerk 15–17, 58, 64–65

The Adventure of the 'Gloria Scott' -

The Adventure of the Musgrave Ritual 28–29

The Adventure of the Reigate Squire -

The Adventure of the Crooked Man 82–83

The Adventure of the Resident Patient 22–23, 25, 28–29, 30–31, 33–34, 42–43

The Adventure of the Greek Interpreter 12–14, 33–34, 35, 38–39, 40–41, 48–49, 53, 61–62, 70–71, 72, 74–75, 76–77, 84, 90

The Adventure of the Naval Treaty 53, 70–71, 74–75, 82–83

The Adventure of the Final Problem 28–29, 33–34, 40–41, 42–43, 48–49

The Hound of the Baskervilles (serialised 1901–02): 12–14, 22–23, 25, 30–31, 33–34, 38–39, 42–43, 45, 56–57, 63, 64–65, 76–77, 82–83

The Return of Sherlock Holmes (thirteen stories, 1903–04):

The Adventure of the Empty House 8–9, 12–14, 28–29, 30–31, 38–39, 64–65

The Adventure of the Norwood Builder 15–17, 61–62, 69, 76–77, 79–80

The Adventure of the Dancing Men 10–11, 90

The Adventure of the Solitary Cyclist 40–41, 44, 51–52, 82–83

The Adventure of the Priory School 20–21, 33–34, 40–41

The Adventure of Black Peter 70–71, 90

The Adventure of Charles Augustus Milverton 33–34, 58

The Adventure of the Six Napoleons 18, 56–57, 61–62, 70–71, 74–75, 90

The Adventure of the Three Students -

The Adventure of the Golden Pince-Nez 12–14, 72

The Adventure of the Missing Three-Quarter 26–27, 32, 42–43, 69

The Adventure of the Abbey Grange 12–14, 40–41, 69, 72, 79–80

The Adventure of the Second Stain 12–14, 53, 56–57

His Last Bow (seven stories, 1908–13, 1917):

The Adventure of Wisteria Lodge* 10–11, 12–14, 19, 61–62, 67, 69

The Adventure of the Red Circle 10–11, 19, 26–27, 32, 58, 70–71

The Adventure of the Bruce-Partington Plans 12–14, 22–23, 46–47, 51–52, 61–62, 73, 76–77

The Adventure of the Dying Detective 42–43, 61–62, 88–89

The Disappearance of Lady Frances Carfax 33–34, 38–39, 51–52, 70–71, 74–75

The Adventure of the Devil's Foot 28–29

His Last Bow 40–41, 61–62

The Valley of Fear (serialised, 1914–15): 48–49, 58, 66, 74–75, 90

The Case-Book of Sherlock Holmes (twelve stories, 1921–27):

The Adventure of the Mazarin Stone 53, 59, 90

The Problem of Thor Bridge 12–14, 30–31

The Adventure of the Creeping Man 90

The Adventure of the Sussex Vampire 15–17, 48–49, 56–57, 66, 69

The Adventure of the Three Garridebs 28–29, 42–43, 70–71, 82–83

The Adventure of the Illustrious Client 12–14, 25, 28–29, 30–31, 38–39, 40–41, 42–43, 56–57, 66

The Adventure of the Three Gables 30–31, 40–41, 59

The Adventure of the Blanched Soldier 15–17, 20–21

The Adventure of the Lion's Mane -

The Adventure of the Retired Colourman 44, 55, 69, 76–77, 90

The Adventure of the Veiled Lodger 70–71, 84

The Adventure of Shoscombe Old Place 26–27, 28–29, 30–31

* *The Adventure of Wisteria Lodge was originally published as A Reminiscence of Mr Sherlock Holmes in two parts; The Singular Experience of Mr John Eccles and The Tiger of San Pedro.*

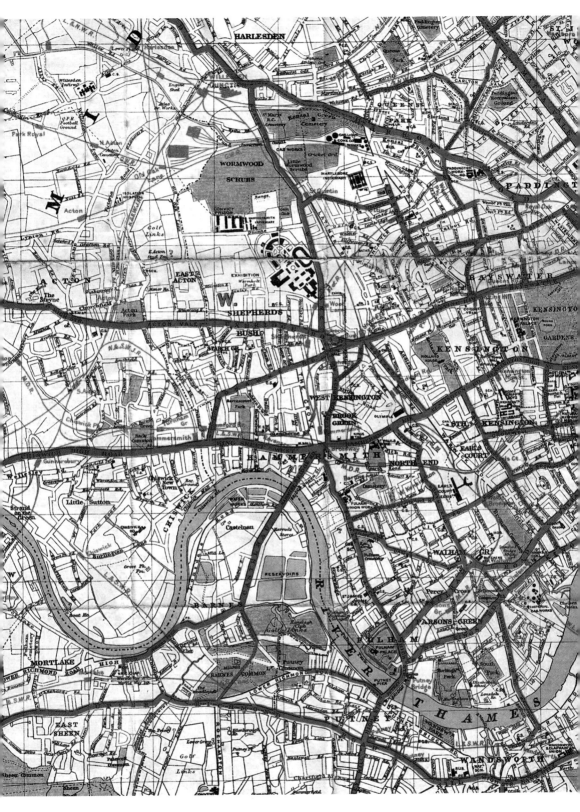

Bacon Pocket Map of London in 1900

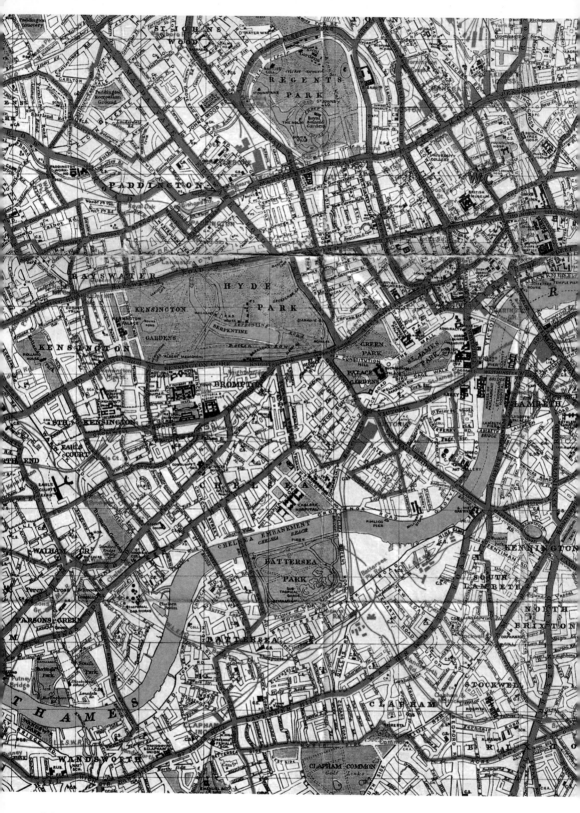

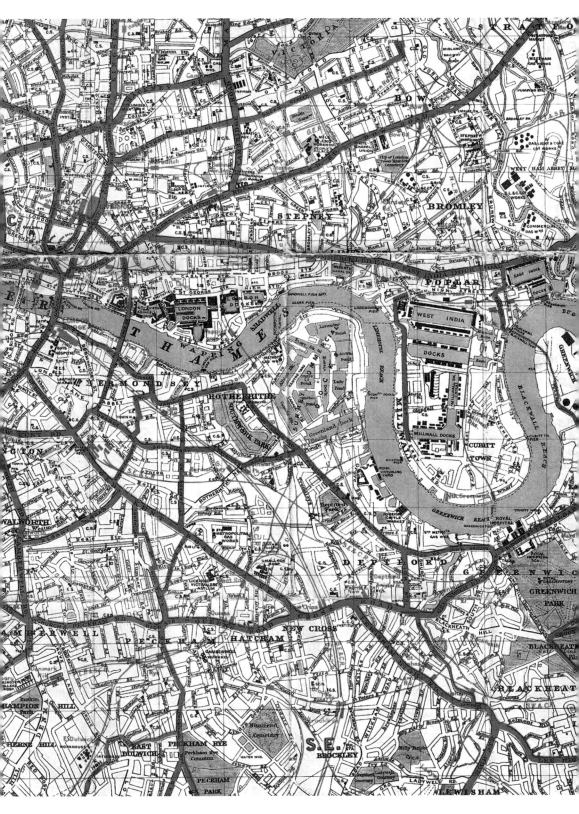

Further reading

It's elementary. See the list on page 92.

Acknowledgements

I would like to thank Campbell McCutcheon (*CMcC*) of Amberley Publishing for commissioning this book and for supplying several of the images from his extensive collection. For additional images I am grateful to the US Library of Congress (*LoC*), Cornell University Library (*CUL*), Ell Brown, Clickos/Dreamstime.com, Doug Neiner, Man Vyi, Mark Hilliary, Pafcool2, Andrew Malzoff/Dreamstime.com, and Jongleur100. Unless otherwise credited, new photography is by the author (*JC*).